IMAGES
of America

OHIO AND ERIE CANAL

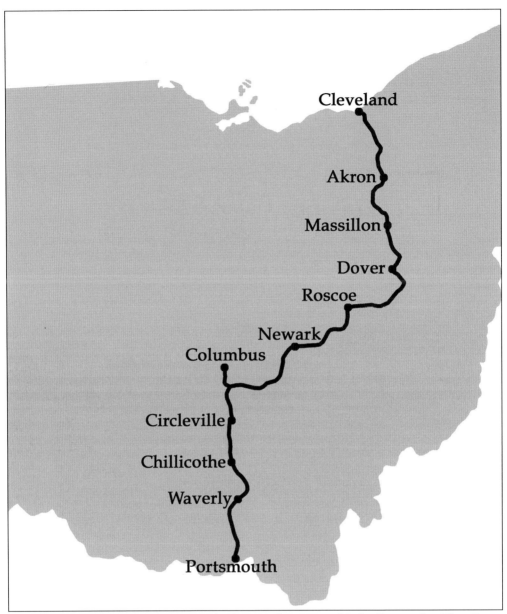

The Ohio and Erie Canal was 309 miles long and connected Lake Erie to the Ohio River. (Author's collection.)

IMAGES
of America

OHIO AND ERIE
CANAL

Boone Triplett

ARCADIA
PUBLISHING

Published by Arcadia Publishing
Charleston, South Carolina

Printed in the United States of America

Library of Congress Control Number: 2014933627

For all general information, please contact Arcadia Publishing:
Telephone 843-853-2070
Fax 843-853-0044
E-mail sales@arcadiapublishing.com
For customer service and orders:
Toll-Free 1-888-313-2665

Visit us on the Internet at www.arcadiapublishing.com

To Big Jug and Hard Rock

CONTENTS

ACKNOWLEDGMENTS

Obviously, a book such as this would not be possible without the help and cooperation of others. This begins with Canal Society of Ohio (CSO) members Bill Oeters, Dave Neuhardt, Dave Meyer, Terry Woods, and Nancy Gulick. They provided images from their personal collections and/or reviewed the text for historical accuracy. Any remaining errors are the sole responsibility of the author.

Also deserving of acknowledgement is Vic Fleischer of the University of Akron Archival Services. In addition to being caretaker of the CSO collection, Vic provided many images from the Louis Baus Canal Photograph Collection (UA-Baus). Chris Hart, museum curator and living historian at Roscoe Village, generously donated his office and allowed full access to the Roscoe Village Foundation (RVF) photograph collection. Mandy Altimus Pond of the Massillon Museum kindly opened up the William Bennett Collection. Ditto for Mary Plazo and Rowan MacTaggart of the Cascade Locks Park Association (CLPA). Randy Norris and Larry Turner of the Portage Lakes Historical Society (PLHS) allowed me to handle the original glass plate negatives of Edwin Bell Howe. (Larry's enthusiasm for the subject of canals is unmatched—and infectious!) Judy James and Rebecca Larson-Taylor of the Special Collections Department at the Akron-Summit County Public Library (ASCPL) were also helpful.

Ultimate thanks should go to individuals like Baus, Bennett, Howe, and Pearl Nye. If these men did not keep the memory of the Ohio and Erie Canal alive, it may have died away completely during the first half of the 20th century.

INTRODUCTION

The United States had secured its independence from Great Britain, but George Washington was concerned about the new nation's future. Immediately after the American Revolution, all trans-Appalachian commerce flowed into British Canada or Spanish Louisiana. The Ohio Country was the key to growth and prosperity. As Washington wrote to the governor of Virginia in 1784, "I need not remark to you Sir, that the flanks and rear of the United States are possessed by other powers, and formidable ones too; nor how necessary it is to apply the cement of interest, to bind all parts of the Union together by indissoluble bonds." These "indissoluble bonds" were canals. Washington proposed in the same letter to "let the courses and distances of it [the Ohio River] be taken to the mouth of the Muskingum, and up that river to the carrying place with Cayahoga [sic]; down the Cayahoga to Lake Erie . . . and with the Scioto also." So Washington not only envisioned the Ohio and Erie Canal, but the cities of Cleveland and Akron, as well.

Ohio became a state in 1803, but progress on canals was slow. A lottery was created to finance navigational improvements along the state's rivers, but few tickets were sold. Then, the War of 1812 intervened. After the war, it appeared that funding for internal improvements might be forthcoming from the federal government, but Pres. James Madison vetoed the Bonus Bill of 1817. This veto meant that it would be up to the states to build such projects. Gov. DeWitt Clinton of New York accepted the challenge, spearheading construction of the 363-mile-long Erie Canal. Connecting the Atlantic Ocean to the Great Lakes, "Clinton's Ditch" was the crowning transportation achievement of its time.

Completed in 1825, New York's Erie Canal changed the landscape in Ohio. Now that a canal to the west was operating, a canal opening up the western interior was the next logical step. Ohio was one of America's poorest states in 1822, but Gov. Ethan Allen Brown was able to get $6,000 authorized to initiate surveys and establish a canal commission. The final route was announced in May 1825. Ohio's canal, from Lake Erie to the Ohio River, would run along the Cuyahoga, Tuscarawas, Muskingum, Licking, Little Walnut, and Scioto Valleys from Cleveland to Portsmouth. (A second canal, the Miami Canal, was the result of a political compromise. It would eventually be extended to Lake Erie by 1845.) The dizzying success of the Erie Canal in New York meant that material, men, and money would not present any barriers for the financially strapped state of Ohio to undertake its grand internal improvement project.

Governor Clinton himself turned the first shovelful of earth during ground-breaking ceremonies for the Ohio and Erie Canal near Newark on July 4, 1825. This act would be repeated millions of times, as mostly Irish immigrants poured into the Buckeye State to work from sunup to sundown for 30¢ a day and a jigger of whiskey under horrendous conditions. The new canal's dimensions were nearly the same as those on the Erie Canal: minimums of 40 feet wide at water level and 26 feet wide at the bottom; a depth of 4 feet; and a 10-foot-wide towpath. Progress was steady, and, two years later, the first section of the Ohio and Erie Canal was completed, from Cleveland to Akron. Ohio governor Allen Trimble and canal commissioner Alfred Kelley were among

dignitaries who traveled on the first boat, the *State of Ohio*. A wild celebration greeted the *State of Ohio* when it arrived in Cleveland on July 4, 1827, as everyone in the cheering crowd realized that the canal would allow them to sell high and buy cheap. In fact, export commodity prices more than tripled overnight.

Similar celebrations greeted the canal as it stretched southward to Massillon in August 1828, Dover in October 1829, Newark in July 1830, and Chillicothe in October 1831. When it finally opened to Portsmouth on October 15, 1832, the completed Ohio and Erie Canal was 309 miles long. It consisted of 14 aqueducts, 155 stone culverts, and 148 lift locks, used to overcome an elevation difference of 1,207 feet. These statistics were subject to change throughout the lifespan of the canal. For example, the number of aqueducts would almost double, to 27. Locks were 90 feet long by 15 feet wide. The cost to build the system, which included a network of feeder and sidecut canals and associated reservoirs, was $7,904,972.

Despite inherent disadvantages, such as a four-mile-per-hour speed limit and seasonal operation, the state-operated canal system was generally successful. Never particularly profitable due to high maintenance costs, the canals, within a generation, transformed Ohio from a backwoods frontier wilderness into the nation's leading state in terms of agricultural output. Real estate values increased by an unbelievable 1,400 percent in Ohio's 37 canal counties from 1826 to 1859, and the state became the nation's third most populous. Receipts on the canals increased steadily, peaking at $799,025 in 1851. Then, the bottom dropped out. Receipts were down to $109,286 by 1861, and the state leased the system to private interests that same year. Railroads, something nobody could have predicted in the age of George Washington or DeWitt Clinton, were the cause. Rail's advantages of speed, year-round operation, and low maintenance costs doomed the canal system.

Still, the Ohio and Erie Canal continued to function. Ohio resumed control in 1878, and the operators of family boats were able to eke out a modest living by transporting commodities such as coal, ice, stone, and timber. There was enough of a niche business from this largely local trade, and from the selling of water rights by the state, that allocations to refurbish the system were started in 1905. This resulted in the entire northern section, from Cleveland to Tuscarawas County, being rebuilt. But the Great Flood of 1913 was the death knell. This greatest natural disaster in Ohio history devastated the canal system, and it would never be rebuilt. Epitaphs of the Ohio and Erie Canal often read: "Born in 1825 and died in 1913."

The Ohio and Erie Canal no longer exists as a viable transportation enterprise, but it continues to endure. Even during the operating era, boat rides, fishing, ice-skating, and swimming were popular canal activities. After the flood, individuals like Pearl Nye and organizations such as the Canal Society of Ohio kept the canals alive. Ralph Regula's "canal walks" brought further recognition and eventually led to the establishment of Cuyahoga Valley National Park and the Ohio and Erie Canalway. Communities along the route are embracing their canal heritage, and the outlook for the canal as a cherished historical and recreational resource is optimistic.

One

CUYAHOGA VALLEY

The northern terminus of the Ohio and Erie Canal was located at Cleveland, with an outlet lock near the mouth of the Cuyahoga River in downtown. There were 44 lift locks between the original northern terminus and the Portage Summit at Akron, but the outlet was moved three miles south to accommodate the Valley Railway in 1878, eliminating Locks 43 and 44. The only weigh lock along the Ohio and Erie Canal was at Cleveland. The city was also home to a toll collector's office.

From Cleveland, the canal route followed the Cuyahoga Valley. Locks were numbered in descending order as the canal climbed toward the summit level, and some were named for the distance from the original terminus at Cleveland. So Lock 41 was Five Mile Lock, Lock 39 was Eleven Mile Lock, and Lock 37 was Fourteen Mile Lock. Other notable Cuyahoga Valley locks included Red Lock (Lock 34), Boston Lock (Lock 32), Deep Lock (Lock 28), Johnnycake Lock (Lock 27), and Pancake Lock (Lock 26). Aqueducts in this section carried the canal across Mill Creek, Tinkers Creek, Cuyahoga River at Peninsula, Furnace Run, and Sand Run. Dam and feeder systems provided water for the canal at Lock 36 near Brecksville (Pinery Feeder), Lock 30 near Peninsula, and Lock 21 at the junction of the Cuyahoga and Little Cuyahoga Rivers. This is the southern extent of the Cuyahoga Valley section.

Towns along the Ohio and Erie Canal in the 34-mile-long Cuyahoga Valley section include Cleveland, Newburgh, Willow, Independence, Valley View, Brecksville, Boston, Peninsula, Everett, Ira, Botzum, and Old Portage.

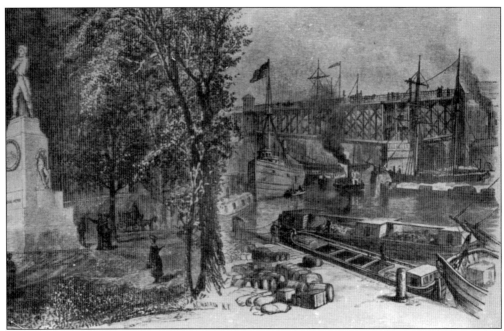

Cleveland, founded by Moses Cleaveland in 1796, was described in an early account as "wilderness surrounded by wilderness . . . an invitation to hardship and helplessness." Canal commissioner Alfred Kelley was largely responsible for establishing the Lake Erie terminus of the Ohio and Erie Canal here in 1825, transforming Cleveland from a struggling village of 500 to the nation's sixth-largest city by 1900. In the above engraving, canal boats are depicted alongside lake vessels at the outlet. The below photograph, taken from the Center Street Bridge, shows where the canal entered the Cuyahoga River (to the right of the dark building near the center). Lorenzo Carter's Cabin in Heritage Park at Settler's Landing marks the site today. The terminus was relocated three miles south in 1878. (Above, CSO; below, RVF.)

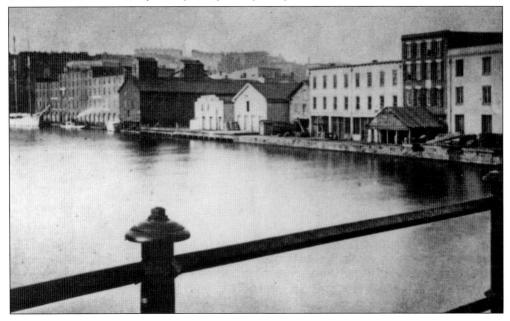

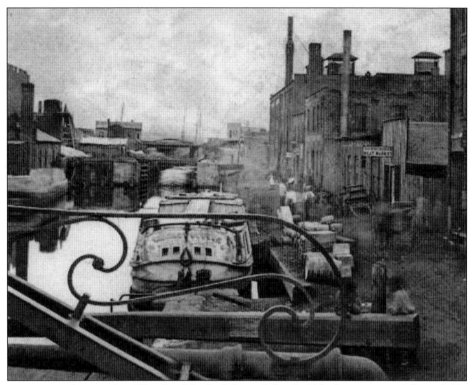

Boats entering the canal at Cleveland locked through Lock 44 before entering Merwin's Basin, pictured above with Lock 43 in the background. Locks 43 and 44 were called sloop locks, since both were larger than the normal 90-foot-by-15-foot canal locks. This allowed for the passage of lake traffic above (south of) Lock 43, where the canal was lined with dry docks and warehouses. The only weigh lock on the canal was located along this stretch near Seneca Street (now West Third Street). The below photograph, showing the canal farther south, looks from Ontario Street toward the Industrial Flats. (Above, courtesy of Dave Meyer; below, CSO.)

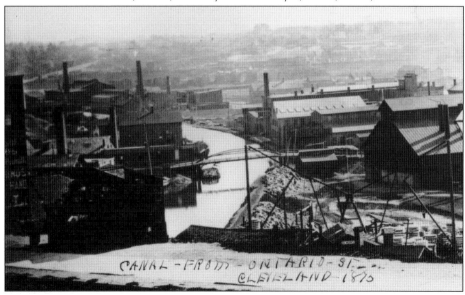

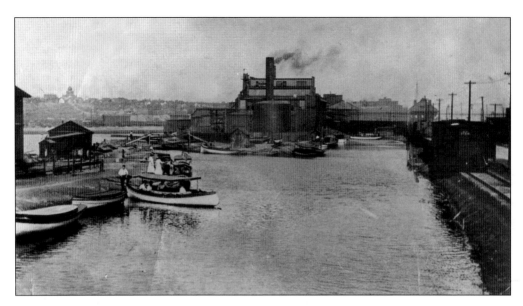

The area shown above became the northern terminus of the Ohio and Erie Canal after 1878. The canal originally extended into downtown Cleveland, but the Valley Railway leased the right-of-way and laid tracks in the filled canal bed. The canal outlet was relocated along Independence Road near the foot of Dille Street, which required a new outlet lock into the Cuyahoga River. This lock, Lock 42, is seen on the left. The river is in the background, and the Grasselli Chemical Company is at center. A stub of the old canal, called the Dog Pond, is at right. Dredges, like the one shown below at the relocated terminus, were essential for keeping the canal clear for navigation. (Above, CSO; below, courtesy of Bill Oeters.)

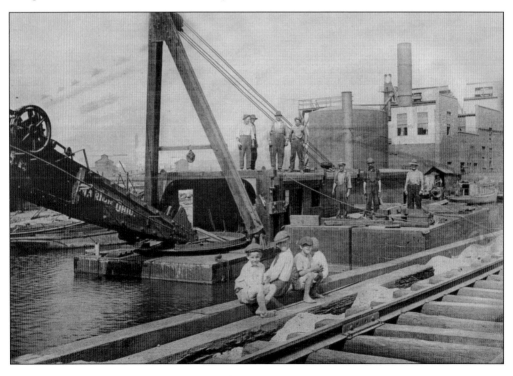

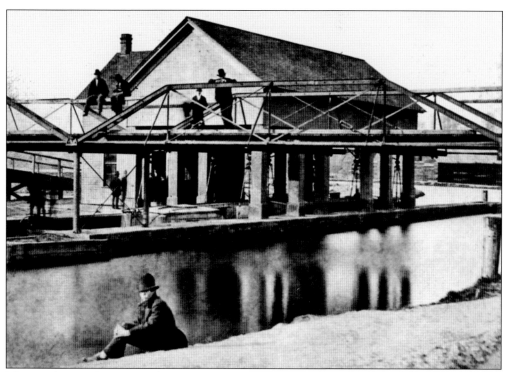

Moving the canal terminus also required moving the weigh lock, shown in these photographs. It was located just above the post-1878 terminus at Lock 42. Boats entered the lock chamber and water was emptied, leaving the boat to rest on a cradle counterbalanced by iron weights. Once the scale was balanced, weight could be determined. Boats were weighed empty to measure a tare weight, which was then subtracted from the weight of a fully loaded boat. In this way, the amount of cargo being carried was determined for toll-collection purposes. (Above, UA-Baus; right, CSO.)

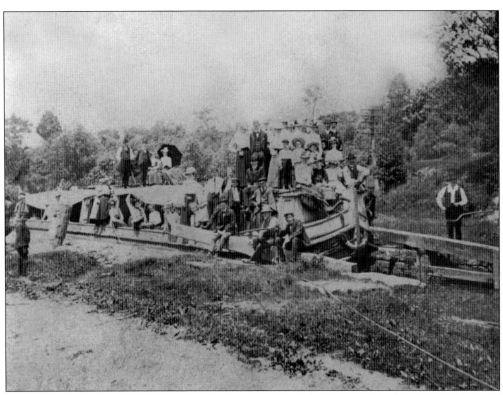

Shown above is a May 30, 1903, outing of the Young People's Society of Christian Endeavor of Bethlehem Church. The group was listed as an "English and Bohemian" congregation in the 1903 Cleveland City Directory. An author of the period relayed a story about how the "Czechs took picnic lunches and walked to the old canal lock." The identity of the lock being described is not known, nor is the lock shown here. The same author wrote about bands joining in on the fun, and that an "enthusiastic drummer once hit his head so hard that he fell overboard." According to the ticket shown below, the ride cost a quarter and turned around at Lock 37. (Both, CSO.)

Y. P. S. C. E. SOCIETY,

of Bethlehem Church,

❧ Canal Boat Excursion, ❧

— TO —

Tinker's Creek, 14 mile lock.

Decoration Day, May 30. 1903.

Boat leaves South Dille Street at 8 A. M. Standard Time.

TICKETS 25 CENTS.

Print. L. Čapek, [UNION PRINTER] 258 Barkwill Av.

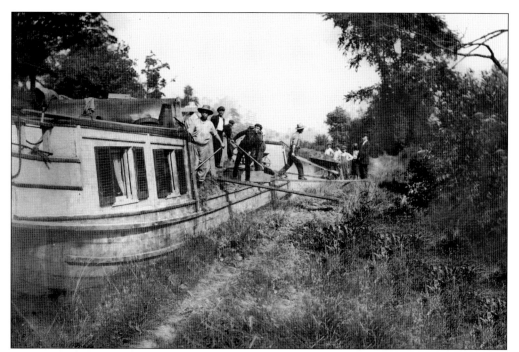

State boats and their work crews were critical for maintenance along the canal. Their responsibilities included repairing holes and leaks (burrowing animals were a particularly vexing problem), clearing debris, removing sediment, mowing canal grass, and maintaining locks, aqueducts, floodgates, and waste weirs. (UA-Baus.)

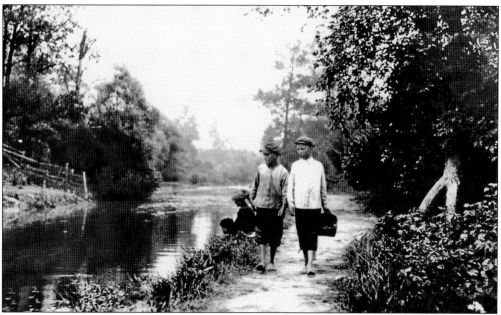

Both of these boys look qualified to be a hoggee. Hoggees along the towpath drove animal teams that pulled canal boats. Some speculate that *hoggee* is derived from the horse commands "haw" (left) and "gee" (right), but journalists may have contrived the term in later years to describe the "colorful" canal era. (UA-Baus.)

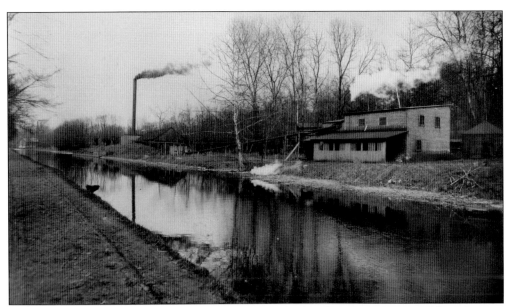

The Austin Powder Works was established in 1833 by five brothers from Vermont. Then, 34 years later, they purchased the Cleveland Powder Company near Five Mile Lock (Lock 41) at Newburgh. A 1907 explosion destroyed that facility (shown here). Despite the setback, Austin Powder remains in operation today, and it is Ohio's second-oldest manufacturing company. (CSO.)

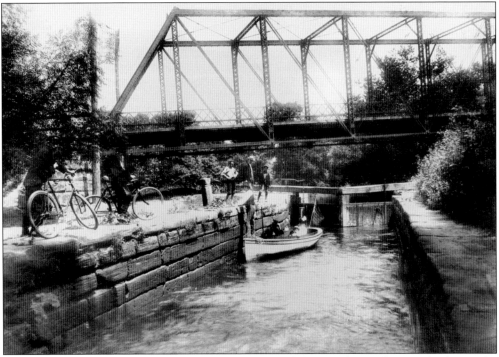

Lock 41 was located at Harvard Avenue, which crossed the canal over the truss bridge in the background. This lock is now buried under a trailhead for the Ohio and Erie Canal Towpath Trail, but the photograph proves that bicycles on the towpath are hardly a modern phenomenon. In earlier times, the adjacent Tielbolt's Dutchman Saloon served thirsty boatmen. (UA-Baus.)

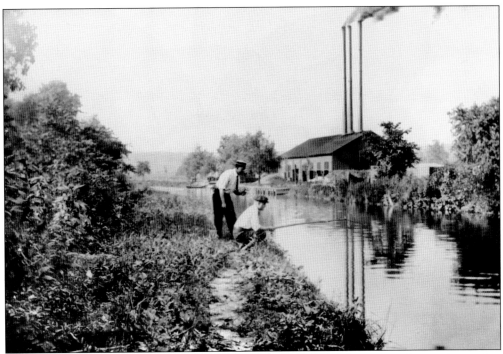

American Steel and Wire leased water from the state until 1998. The company's pumping station (pictured) ran on coal delivered by canal boats before the 1913 flood. Ohio still generates revenue from the canal by leasing water to industry. A couple of golf courses also continue to purchase water from the state. (UA-Baus.)

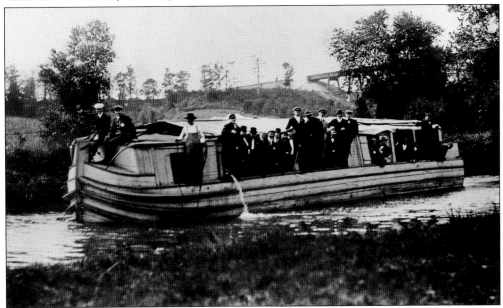

Near the American Steel and Wire pumping station is the Short Line railroad trestle, spanning the canal in the background of this photograph. Both the pump house and trestle are existing landmarks in the Hidden Valley, an area administered today by Cleveland Metroparks as the Ohio and Erie Canal Reservation. (UA-Baus.)

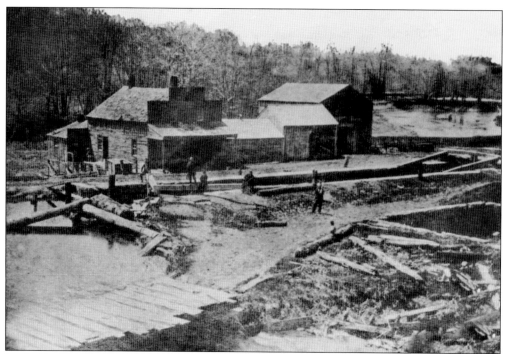

Lock 40 is the northernmost surviving lock on the Ohio and Erie Canal, found today almost under an Interstate 77 overpass. The area was once the former community of Willow. A general store, keeper's home, storage sheds, and stables for the animals represent a typical canal lock layout. (UA-Baus.)

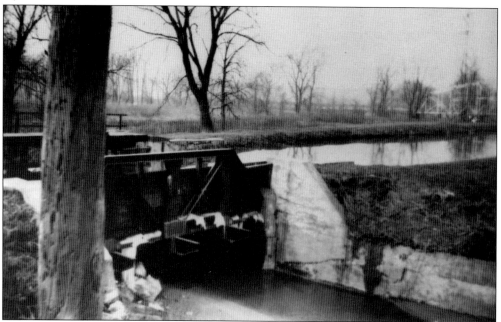

Also extant is the northernmost aqueduct on the canal, a 42-foot-long, single-span structure that still carries a watered section across Mill Creek. Just visible in the right background is the Brecksville Road Bridge, where Interstate 77 now crosses the canal and the Cuyahoga River. (RVF.)

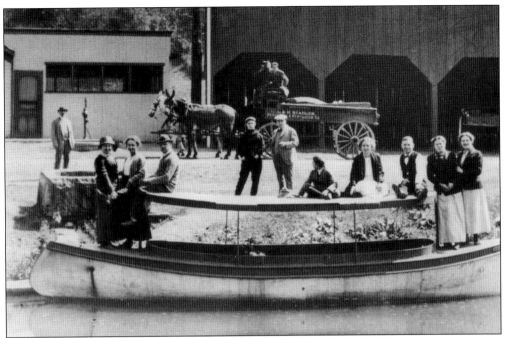

In the early 20th century, excursion boats operated from the Dog Pond at the relocated outlet near Cleveland. Zimmerman's Tavern (pictured) was a popular picnic spot. Earlier, it was notorious for its drinking, fighting, and gambling activities. Today, it is the site of an upscale restaurant. (CSO.)

Located beside milepost 11, Lock 39 is known as Eleven Mile Lock. It now sits just inside the northern boundary of Cuyahoga Valley National Park. Shown sitting on the gate balance beam at Lock 39 are, from left to right, Dr. Aardon P. Hammond, his wife Florence Hammond, and Louise Baus. Louise's husband, Louis Blaus, assembled an impressive canal photograph collection in the early 1900s. (RVF.)

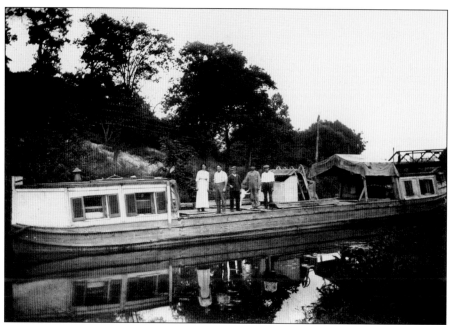

State boats are recognizable by cabins on both ends and a flat deck in the middle. In the above photograph, Charles and Cora Stebbins (left) and their crew stand on a state boat at Stone Road in Independence Township. The foreman and his family lived in the cabin at the stern, while the crew bunked at the forward end. The crew maintained the canal, but the boats themselves also required upkeep. Dry docks, such as the one shown below, were constructed for this purpose. Boats were floated into place, then the water was drained out, leaving the boat to sit on wooden sawbucks so that hull repairs could be made. This is McMillan's Dry Dock at Stone Road. (Above, UA-Baus; below, courtesy of Bill Oeters.)

Known famously as Hell's Half Acre, this 1840s structure at Lock 38 in Valley View now serves as the National Park Service's Canal Visitor Center. Over the years, Hell's Half Acre has been a dance hall, farmhouse, hotel, blacksmith shop, and tavern. Oddly, there is no evidence to support that it was ever a lock tender's residence. (UA-Baus.)

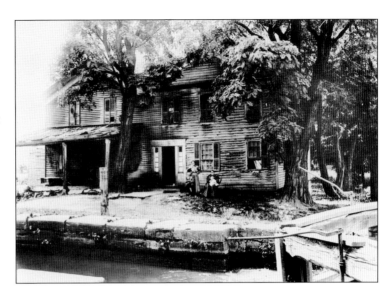

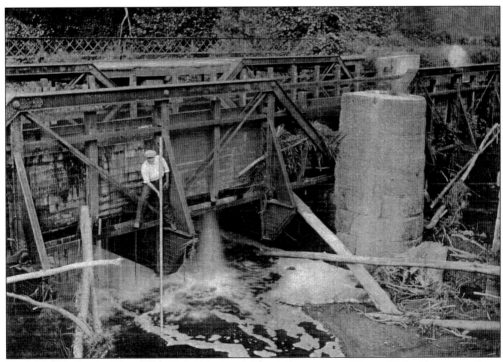

Tinkers Creek, the Cuyahoga River's largest tributary, was crossed by a 95-foot-long aqueduct. Like the one at Mill Creek, it survives. Tinkers Creek Aqueduct has been rebuilt several times over the years, most recently by the National Park Service in 2011. It is shown here in 1916. (Courtesy of Bill Oeters.)

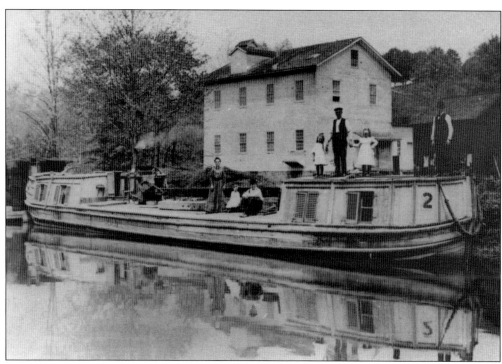

In the above photograph, *State Boat No. 2* is moored at Alexander's Mill beside Lock 37. Mills such as this, once commonplace along the canal, are a rarity today. A spillway, or regulating channel, was the perfect location for a mill, providing plenty of waterpower for turning grist stones, which ground grain into flour. Andrew and Robert Alexander built the mill in 1853, and it was sold to Thomas and Emma Wilson in 1900. The mill continued to use waterpower until 1970, and the equipment remains in place. Wilson's Feed Mill still operates in suburban Valley View. The mill is at the left in the below photograph of Lock 37. (Both, CSO.)

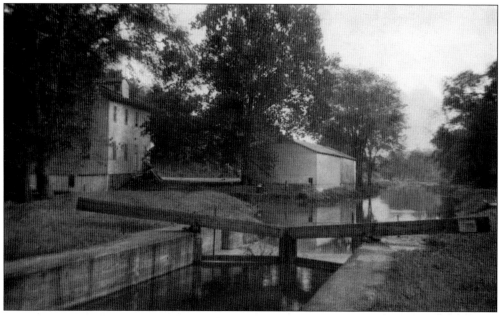

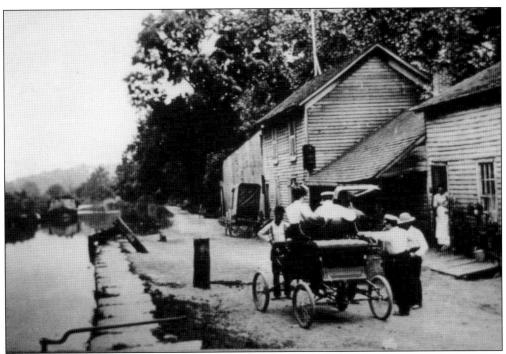

Like Lock 39, Lock 37 sits beside a canal milepost, hence its common name, Fourteen Mile Lock. V. Vanoucek operated a grocery store and tavern along the narrow strip of land between the canal and the river. Vanoucek is likely one of the individuals inspecting the automobile in the above photograph, which faces south at Lock 37. The below photograph was taken from the bow of a canal boat. A mule team can be seen on the towpath in front of Vanoucek's buildings. The floodgate in the left foreground, where the small boat is tied up, remains in operation today. (Above, RVF; below, CSO.)

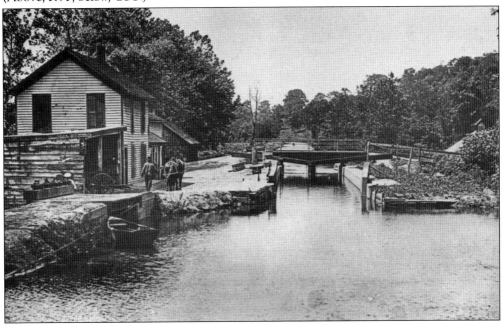

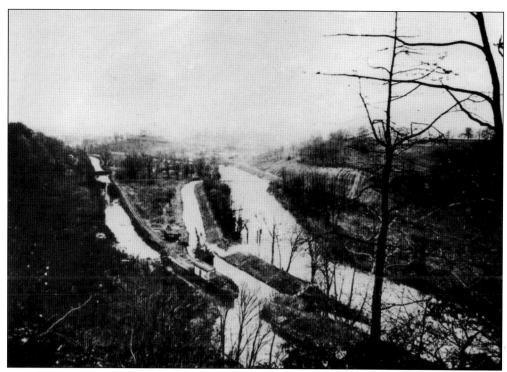

An adequate water supply is critical for the operation of any canal. Reservoirs at the highest levels were one source, but rivers along the way had to be tapped as well. One such arrangement was the dam and feeder system at Brecksville (above). This bird's-eye view shows, from left to right, the Ohio and Erie Canal, Pinery Feeder, and Cuyahoga River. Lock 36 is in the foreground. A dam on the river diverted water into the feeder, which supplied the canal. Gates for controlling flow were at either end. This system still functions. The below photograph is captioned "Outing at Brecksville Station, 1881." The Valley Railway station had just opened when this photograph was taken. The iconic Brecksville-Northfield High Level Bridge, at this location today, did not come along until 1931. (Above, CSO; below, UA-Baus.)

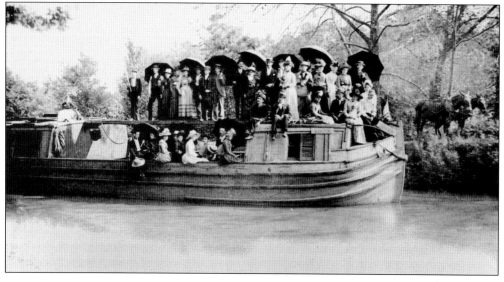

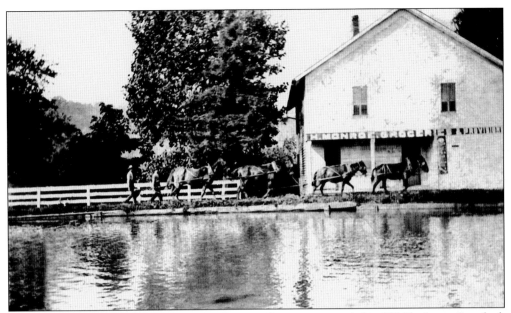

Boston, one of the oldest communities in Summit County, was settled in 1806 by James Stanford. The village flourished for a time from its boatbuilding and milling industries, but the 1913 flood washed away its prosperity. Today, Boston is nestled in the center of Cuyahoga Valley National Park. During the canal era, it earned a somewhat dubious reputation, thanks to the efforts of local counterfeiter and justice of the peace James Brown. H. Monroe's grocery store (above) stood beside the towpath at Lock 32. The building was also a hotel, post office, and schoolhouse. Looking south from Lock 32 (below), the Boston Land and Manufacturing Company Store can be seen in the distance. Built in 1836, the building now houses the National Park Service's Boston Store Visitor Center. (Both, UA-Baus.)

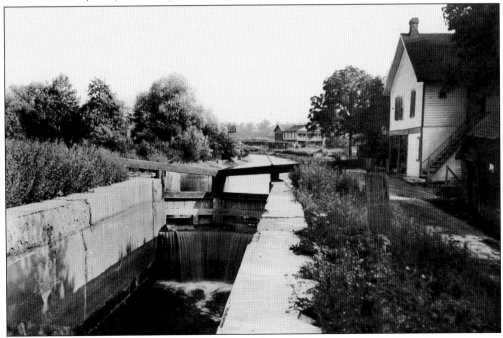

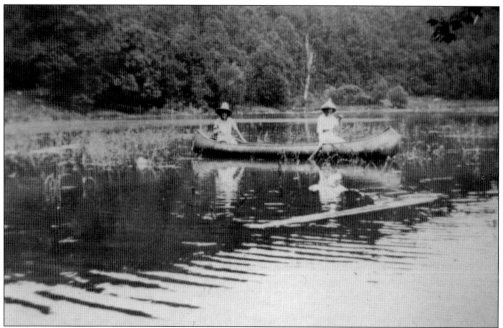

Topography sometimes allowed the canal to exceed its 40-foot minimum width specification, resulting in wide spots, or basins. The ladies shown above are canoeing on Stumpy Basin. A boardwalk now carries the Towpath Trail through Stumpy Basin, an ecological marshland. The basin's outline can still be determined, but it has been encroached by the Cuyahoga River and Ohio Turnpike. Ice was once harvested from Stumpy Basin during the winter months and shipped on canal boats in the days before refrigeration. The spillway for Lock 31 (below) emptied into the basin. This lock was called Lonesome Lock, probably because of its isolated location. (Above, RVF; below, CSO.)

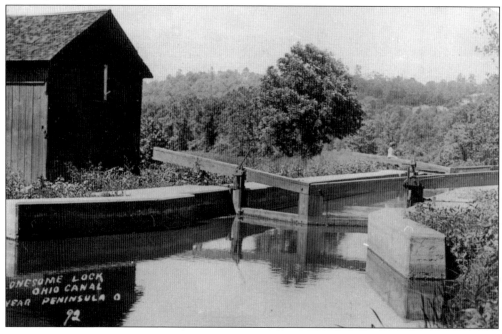

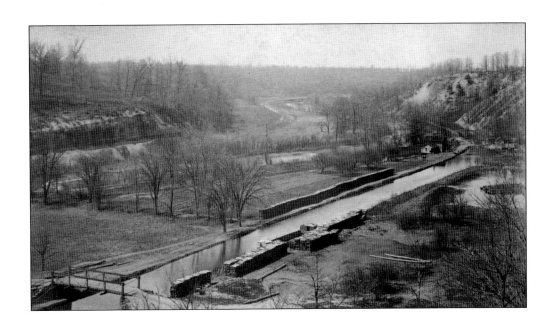

Stacks of lumber line the towpath near Peninsula (above). In the far distance is Lock 30, where there was a nearly identical feeder system to the one at Brecksville. The V-shaped feeder dam (below) was constructed of a timber crib framework, filled with stone, and covered with wood planking. The Peninsula feeder dam has been removed, but the Pinery dam and feeder system at Brecksville still function. American Steel and Wire modified the Pinery dam in the 1950s, so it no longer has the V shape. The gentleman sitting on the dam abutment is believed to be a nephew of Pearl Nye, famed canal balladeer. (Both, CSO.)

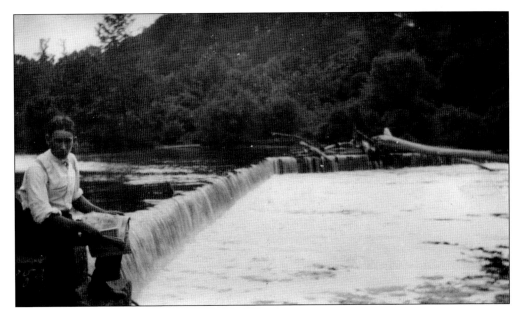

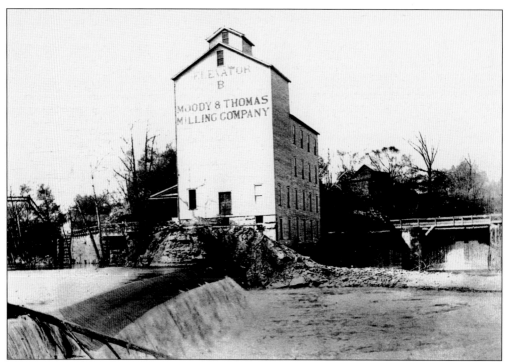

The above photograph shows the Main Street Bridge (left), Moody and Thomas Milling Company (center), and Peninsula Aqueduct (right). The canal crossed the Cuyahoga River here, passed behind the mill, and went under the Main Street Bridge. Just beyond the photograph to the right was Lock 29, which passed directly into the aqueduct flume. Peninsula was settled in 1818 and officially surveyed in 1837 by Herman Bronson. Ironically, the namesake peninsula was eliminated by the Valley Railway in 1880. Several business ventures prospered at Peninsula during the canal era, including boatbuilding, brick making, lumbering, milling, quarrying, hotels, and taverns. In operation for nearly a century, the five-story Peninsula Mills building, also seen below, was destroyed by fire on December 26, 1931. (Both, UA-Baus.)

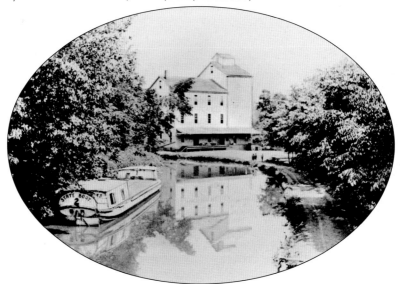

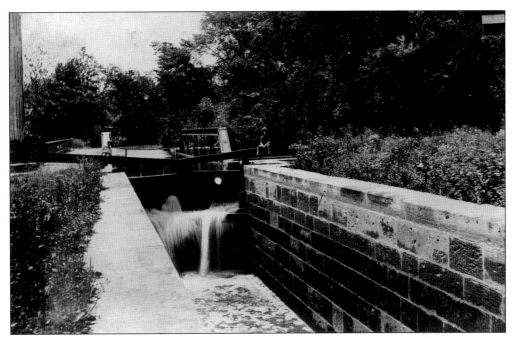

During the 1905–1909 state refurbishment of the canal system, every lock along a 100-mile stretch in northern Ohio was reconstructed of concrete except this one. Rebuilt of stone in 1882, Lock 29 did not require an overhaul. It remains notable for its mason's marks. Both the 82-foot-long aqueduct and Peninsula Mills (at extreme left) are visible in the background. (CSO.)

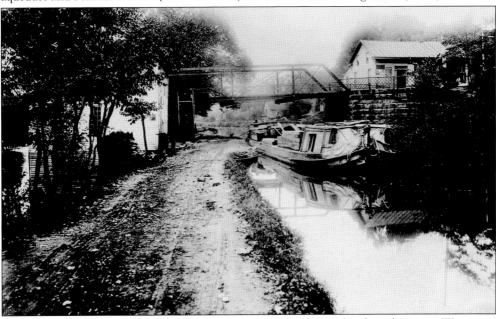

The *Banner* is tied up under the Main Street Bridge. Jacob Barnhardt and Lawson Waterman operated boatyards that churned out as many as 32 canal boats in 1863. When this business waned, Peninsula evolved into a sleepy backwater village. That changed with the establishment of Cuyahoga Valley National Park, which is easily the most-visited area along the canal today. (UA-Baus.)

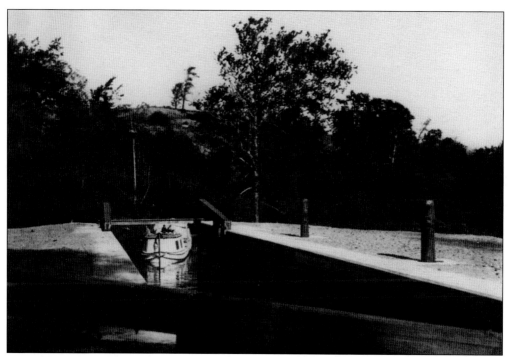

A southbound boat approaches Lock 28, called Deep Lock for its reported 12-to-17-foot lift. Once inside the lock chamber, the gates behind the boat closed. Wickets were then used to let water into the lock, lifting the boat. Upstream gates in front of the boat were then opened, allowing the journey to continue. Snubbing posts were used to steady the boat in the lock chamber. (CSO.)

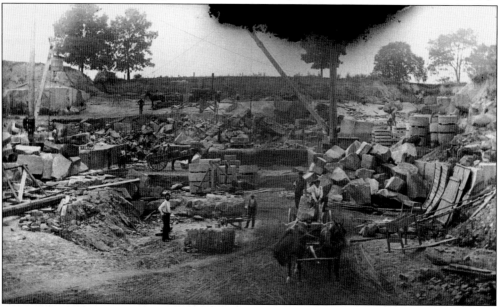

Quarries were essential for canal construction and maintenance, as most structures were built of stone before the widespread use of concrete in the early 20th century. This is Deep Lock Quarry, named after the local canal lock. Operated by the Cleveland Stone Company, the property was converted into a park in 1934. (PLHS.)

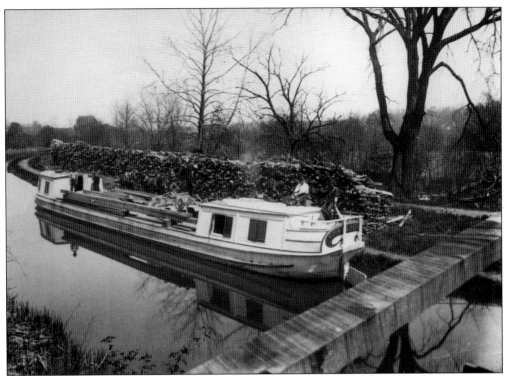

Photographer Edwin Bell Howe took an extraordinary series of images along the canal during the 1890s. Thought to be lost, the original glass plate negatives were rescued from an attic garage by the Portage Lakes Historical Society in 2008. Howe was the grandson of Richard Howe, longtime resident engineer on the Ohio and Erie Canal. Richard Howe's historic downtown Akron residence is now home to the Ohio and Erie Canalway Coalition. The Howe family farm was located at Ira, south of Peninsula. These photographs of boats loaded with lumber (above) and coal (below) were taken near Everett, where Lock 27 was located. This lock was called Johnnycake Lock, because passengers on a canal boat were forced to subsist on johnnycakes for several days when the canal washed out at nearby Furnace Run. (Both, PLHS.)

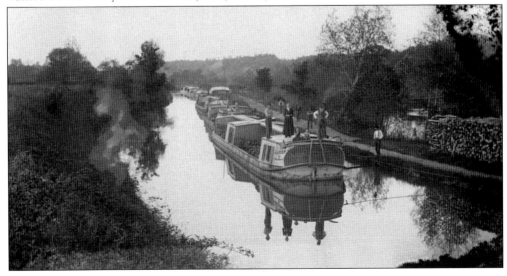

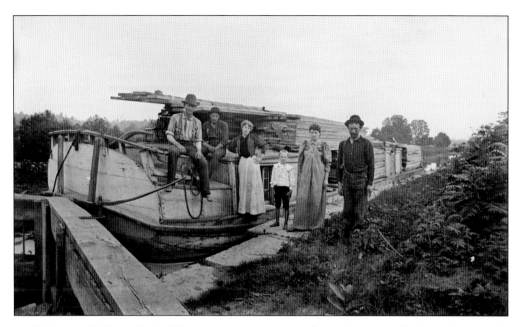

Lock 26 was called Pancake Lock for similar reasons as the johnnycake story. The above photograph, showing a lumber boat in the Lock 26 chamber at Ira, may be the most representative ever taken of an Ohio canal family. Note the rocking chair under the overhanging boards for the person manning the tiller. The tiller counteracted the pull of the towrope, keeping the boat from steering into the bank. The same boat is seen below, with the same people (including the same hat!), at the same lock, heading in the same direction. But the time period is different. The boat has been christened the *Ben Harrison* and even has a portrait of the 23rd president. Harrison served from 1889 to 1893, which helps to date the photograph. (Both, PLHS.)

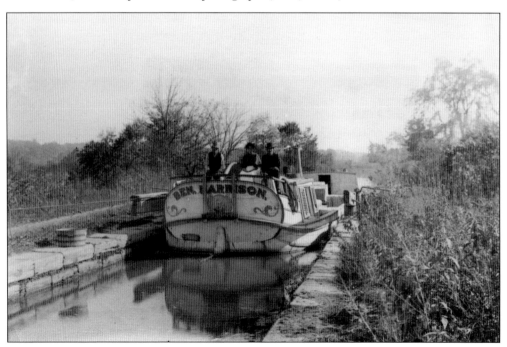

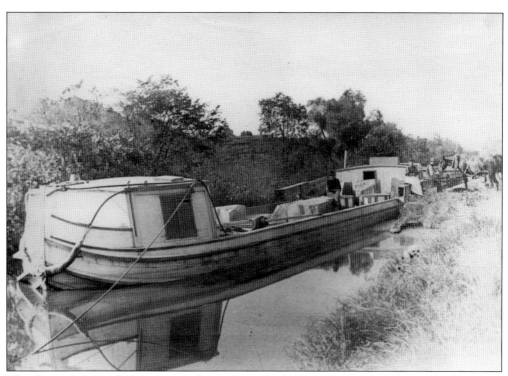

The above photograph shows a state boat exiting Lock 25 at Botzum. Also known by the names Buckeye and Niles, the community was located near the mouth of Yellow Creek, where the canal crossed over an 18-foot stone arch culvert. John A. Botzum operated a general store and lent his name to the nearby railroad station. The hopelessly overloaded boat shown below is a favorite of canal historians. It has a center cabin, which is absent on the state boat. This is the basic three-cabin freighter, the workhorse boat for hauling cargo along the canal. The center cabin was for spare animal teams. Piles of wood obscure the catwalk across the top. (Both, PLHS.)

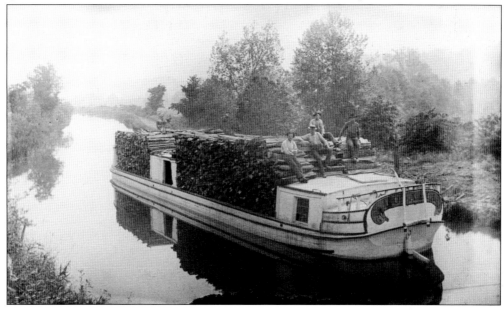

The exact location of this Botzum scene may be determined from period survey maps, which show the farmhouse, shed, barn, and fence. The property is occupied today by the City of Akron Sewage Treatment Plant. Through here, the canal has been filled by Riverview Road and a trunk sewer line. (PLHS.)

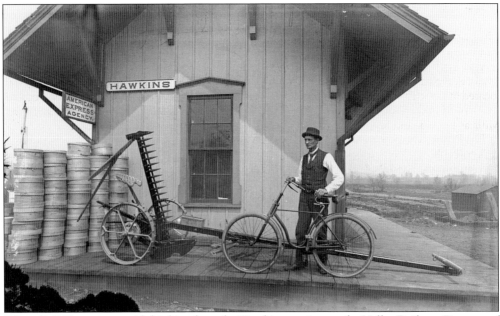

Edwin Bell Howe poses with his bicycle at the Hawkins station on the Valley Railway. Because of another community, called Haskins, the town's name was changed to Ira. Edwin's brother Frank operated a printing press at Ira, and the Howe family also ran the post office. Samuel McNeil's cheese factory was north of Lock 26, where a beaver marsh is now located. (PLHS.)

Two

CASCADE LOCKS
AND PORTAGE SUMMIT

The historic Cascade Locks section began at Lock 21, at the confluence of the Cuyahoga and Little Cuyahoga Rivers. From here, the Ohio and Erie Canal climbed 204 feet to the Portage Summit level at Lock 1 in downtown Akron. The distance from Lock 16 to Lock 1 was only a mile and a half. A feeder dam supplemented the water supply at Lock 16, and Mustill's Grocery Store was located at Lock 15. Continuing its ascent, the canal passed through Akron's Cascade Valley and its string of mills: Cascade Mills at Lock 14, Aetna Mills at Lock 11, City Mills at Lock 9, Center Mills at Lock 6, and Stone Mill at Lock 5. Akron's boatbuilding industry was centered at Lock 2. The Pennsylvania and Ohio Canal joined at Akron via the Lower Basin between Locks 1 and 2. A toll collector's office was near the junction.

Beginning at the Upper Basin south of Lock 1, the canal stretched for nine miles along the Portage Summit level. At the southern end of Summit Lake, the canal ran through the lake, with a floating towpath for mule teams to pull boats. The Portage Lakes reservoirs (East, Long, North, Turkeyfoot, and West) provided water for the canal at its summit level through the Long Lake Feeder. The summit level ended at Lock 1 (south) in Barberton.

Towns along the Ohio and Erie Canal on the 12-mile-long Cascade Locks and Portage Summit section include Cascade (North Akron), Akron, Kenmore, New Portage, Barberton, and Wolf Creek.

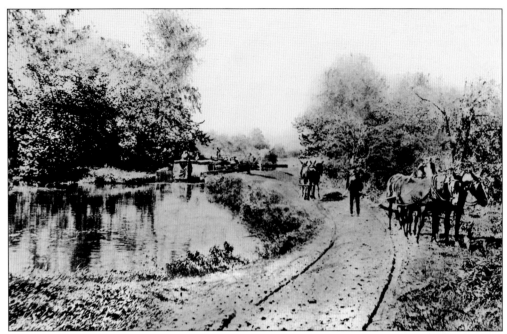

Locks 20 (above) and 21 were the first in a great staircase of locks that raised the Ohio and Erie Canal into Akron. Future president James Garfield was allegedly knocked into the canal while fighting here during his six-week stint as a mule driver on the packet boat *Evening Star*, and he nearly drowned. Later a city dump, this area has been reclaimed, but both locks are buried. Coal from Tallmadge was loaded onto cargo boats in the vicinity of Lock 19. Farther up the staircase was Lock 17 (below), where a distillery was once located. Dam and feeder systems operated at both Lock 21 and Lock 16. (Above, UA-Baus; below, CSO.)

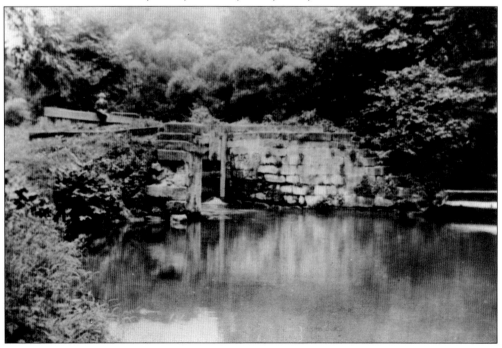

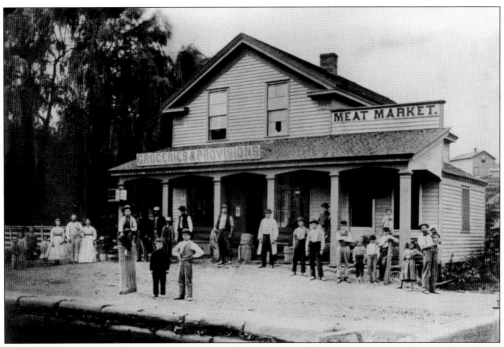

An 1856 map shows five grocery stores along the canal between Locks 14 and 19. These establishments catered to passengers on canal boats waiting to ascend the staircase of locks into Akron. Boats needed about 10 minutes to negotiate a single lock. A general store was run by Joseph and Sarah Mustill at Lock 15. It was famous for its English beer, and a customer once fell into Lock 15 with a $2.50 barrel of whiskey. (The alcohol was reportedly saved during the ensuing rescue effort. No word on the customer.) Restored to its c. 1860 appearance, the Mustill Store is now headquarters for the Cascade Locks Park Association and contains a canal-themed museum. The Mustill Store is photographed during its heyday (above) and in leaner times (below). (Above, CLPA; below, CSO.)

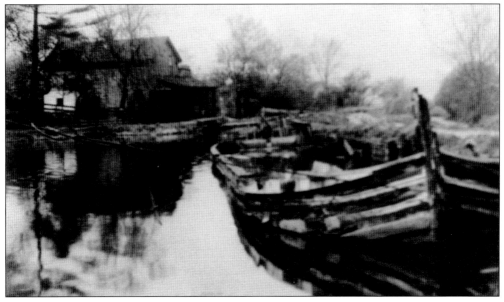

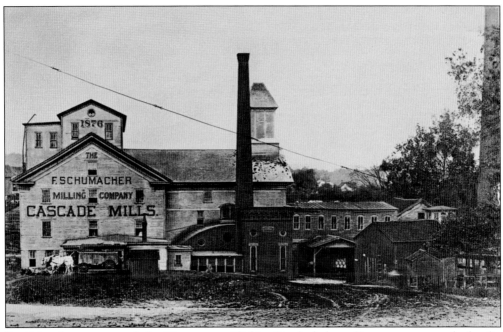

Realizing that water equaled milling power, Eliakim Crosby led an effort to construct a hydraulic millrace that paralleled the canal between Lock 5, where Crosby established his five-story Stone Mill in 1832, and Lock 14. This precipitated a string of mills, the finest of which was Cascade Mills (above) at Lock 14. Ferdinand Schumacher, whose German Mill provided rolled oatmeal flakes for Union troops during the Civil War, purchased Cascade Mills in 1868 and fitted it with a 35-foot-diameter waterwheel. A replica of Schumacher's gigantic waterwheel is in an interpretive park at the site today. The distance between Locks 13 and 14 (below) was the shortest between any on the entire canal. The railroad trestle in the background now carries the Cuyahoga Valley Scenic Railroad over the canal. (Above, CLPA; below, CSO.)

Another active rail trestle crosses the canal at Lock 11. The trestle pictured above was replaced in 1926, but the stone foundations remain. A covered bridge now exists in place of the smaller bridge directly over the lock chamber. Both carried the towpath from one side of the canal to the other. Lock 11 bears the inscription "1907," the year this lock—and others in the Cascade Locks section—was rebuilt with concrete. The Aetna Mills (below), first established at Lock 11 in 1833, was operated by Philo Chamberlain during the booming Civil War era. This industrial valley was the independent town of Cascade, or North Akron, until it merged with Akron in 1836. Main Street in modern-day Akron makes a jog where the "Two Akrons" were joined. (Above, CSO; below, CLPA.)

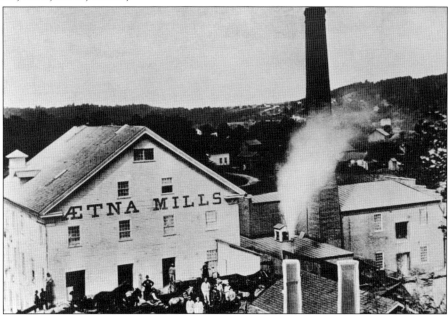

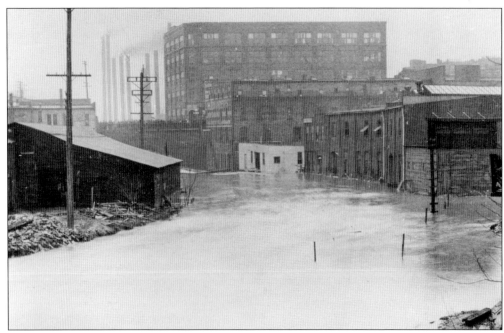

Yet another Akron mill, City Mills, was located at Lock 9. The eight-story Hower Building, shown above during the Great Flood of 1913, later occupied this site. Left of the Hower Building in the distance are the stacks of the Beech Street power plant at Lock 10, operated by Northern Ohio Traction and Light. The power plant was demolished in 2005. Lock 8 (below) was more commonly known as Stone Arch Lock, in reference to the bridge that carried Market Street over the canal. Because lock gates backed up tremendous volumes of water during the flood, a decision was made to dynamite the locks. The dynamiters were a little overzealous at Lock 8, as damage to the adjacent building was unintentional. (Both, CSO.)

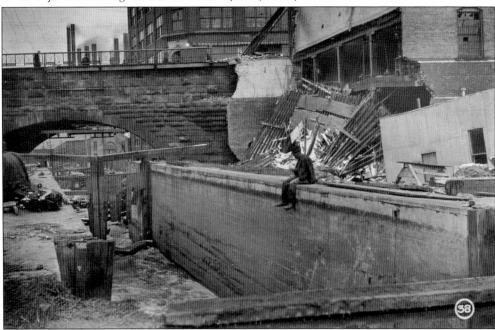

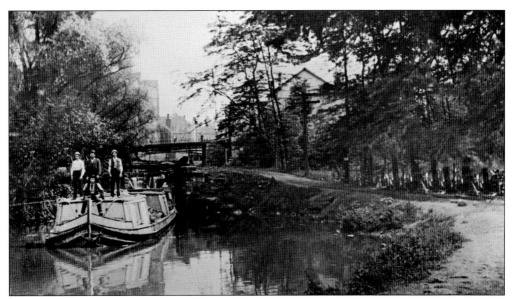

Both of these photographs are looking south into downtown. Visible in the above photograph, behind the boat in the basin above Lock 7, are the Quaker Oats factory and Ash Street Bridge. Obscured by trees, these structures can be seen more clearly in the below photograph. Lock 6 is in the foreground. Center Mills at Lock 6 was incorporated into the powerhouse at Quaker Oats, while Crosby's original 1832 Stone Mill was at Lock 5 (background). Quaker Oats came about when Ferdinand Schumacher's massive, eight-story Jumbo Mill complex burned down in 1886. Lacking insurance, Schumacher was forced to consolidate with his competitors, forming the American Cereal Company. This became Quaker Oats in 1901. All of the structures in this area have been erased by the Akron Innerbelt freeway. (Above, CLPA; below, RVF.)

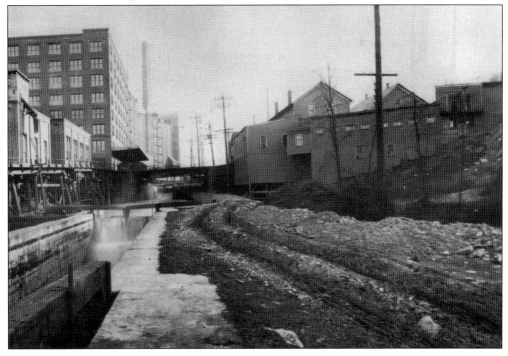

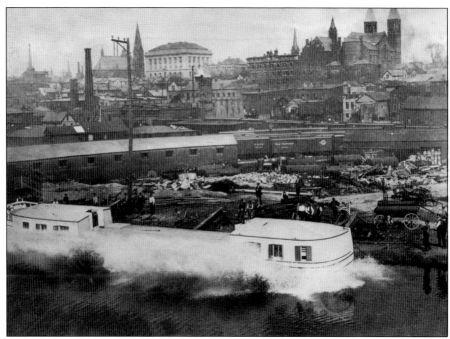

Boatbuilding activities in Akron were centered at Lock 2. The first boat to travel on Ohio's canal system, the *State of Ohio*, was built at the Lower Basin by the Wheeler Brothers and launched on July 3, 1825. It carried Gov. Allen Trimble, canal commissioner Alfred Kelley, and other dignitaries to Cleveland, where a grand celebration was held. The last boat splashed into the canal in 1906. It is seen here being launched (above) and on the water (below). A steel-skeletal canal boat replica at Lock 2 Park recognizes Akron's rich boatbuilding heritage. Lock 2 has been retrofitted with gates, but it is not functional. Nearby at Lock 3 was the American Marble and Toy Manufacturing Company. (Both, CSO.)

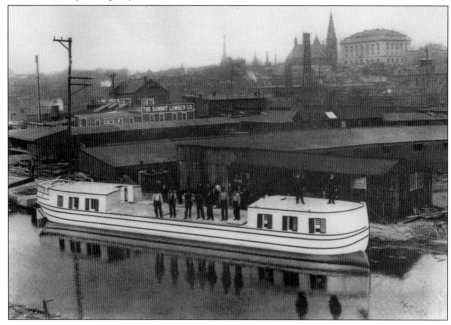

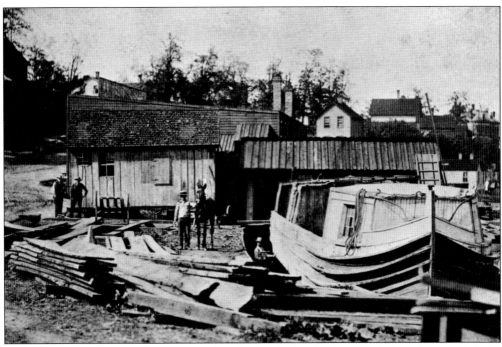

Above, the *Narragansett* is being repaired in the dry dock at Lock 2. The below photograph looks south toward Exchange Street. The dry dock is at right, between the lock and the spillway. Gen. Simon Perkins acquired a considerable amount of land here in the early 1800s by paying off a $4 tax debt. Along with Paul Williams, Perkins mapped out a new town on the site and named it Akron, derived from the Greek word *akros*, meaning "high place." Early Akron, in contrast to heavily industrialized Cascade or North Akron, revolved around canal-related businesses such as boatbuilding, dry docks, lumber mills, and warehouses. Grocers, hotels, and taverns sprang up as well. (Above, CLPA; below, CSO.)

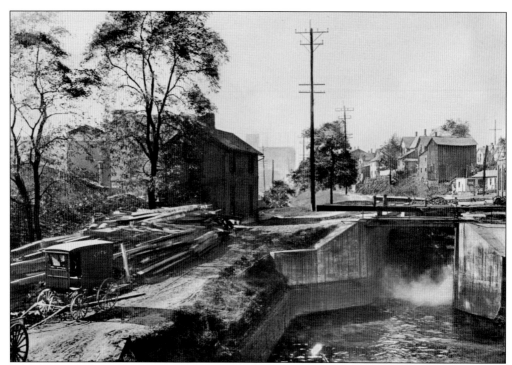

Lock 1 (above) sits at the Portage Summit level, 395 feet in elevation above Lake Erie at Cleveland. The lock functions today as a water-regulating structure and is maintained by the Ohio Department of Natural Resources. Across Exchange Street from Lock 1 is the 1836 Richard Howe House, a visitor information center and headquarters for the Ohio and Erie Canalway Coalition. Howe was resident engineer on the canal from 1826 to 1850, and he was the grandfather of canal photographer Edwin Bell Howe. The Pennsylvania and Ohio Canal (below) was completed in 1840 and abandoned in 1873. It provided a water route to Pittsburgh via the Mahoning Valley and ran along Main Street in Akron, the western terminus of the Pennsylvania and Ohio Canal. The canal junction was at the Lower Basin, just north of Lock 1. (Both, CLPA.)

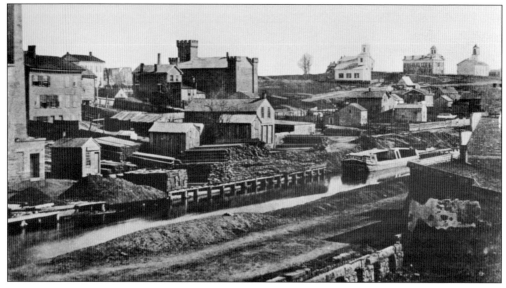

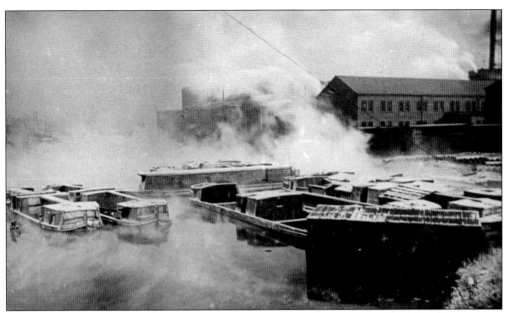

Above Lock 1 on the Portage Summit level was the Upper Basin, which was converted into a canal-boat graveyard (above) after the 1913 flood. Before that, it was the birthplace of the rubber industry. Akron city leaders were able to lure Benjamin Franklin Goodrich and his fledgling rubber fire-hose plant to Akron in 1870 with the promise of a cheap and abundant water supply from the canal. B.F. Goodrich Company (below) became profitable in the 1890s, manufacturing bicycle tires. Business really took off when Henry Ford started automobile assembly lines in Detroit, thus making Akron the "Rubber Capital of the World." (Above, CSO; below, CLPA.)

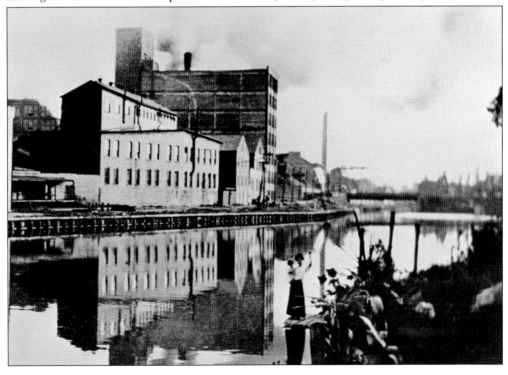

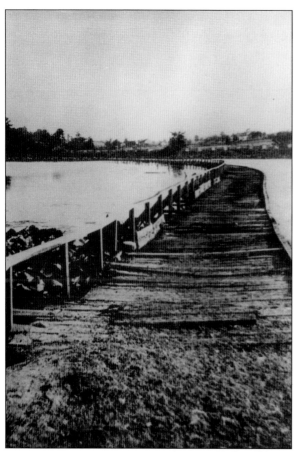

Summit Lake was once three times larger than it is today, but canal engineers drained the lake by about five and a half feet to avoid building additional locks. "Lake" is a bit of a misnomer, as the area was actually a tamarack swamp before the canal came through. So much mud and muck remained after draining that there was no solid ground available for a towpath, necessitating the construction of a floating boardwalk (left) along the southeastern lakeshore for tow animals. This floating towpath was reconstructed in 2009. Excursion steamers to the Portage Lakes during the 1920s (below) did not need a towrope. Summit Lake was once a popular recreation area, with an amusement park, beer halls, beaches, boat docks, casinos, and a vaudeville stage. (Both, CSO.)

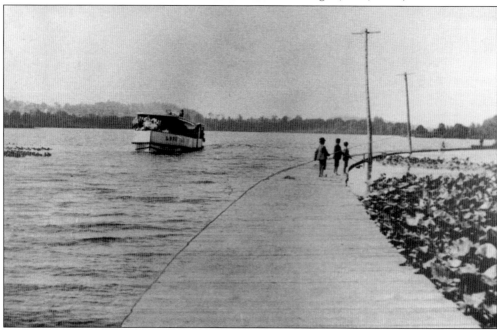

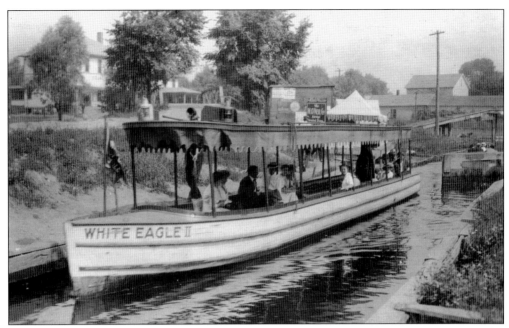

Increased water demand rendered Summit Lake insufficient by 1840, leading to the creation of the Portage Lakes reservoirs. A feeder from Long Lake continues to supply the canal with water. The *White Eagle II* (above) demonstrates that the feeder was at one time navigable, but a lock that once allowed for passage of boats from the canal to the Portage Lakes was eliminated. Young's Hotel (below), built around 1850 and razed in 2011, was located opposite the Long Lake feeder outlet at the true summit level of the Ohio and Erie Canal. Water entering the canal here flows in either of two directions: north down the Cuyahoga Valley and eventually into the North Atlantic Ocean via the Great Lakes and St. Lawrence River or south down the Tuscarawas, Muskingum, Ohio, and Mississippi Rivers into the Gulf of Mexico. (Above, courtesy of Dave Neuhardt; below, PLHS.)

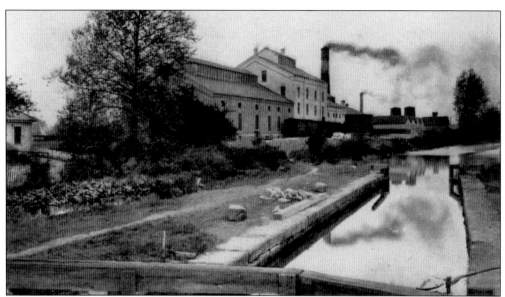

Ohio Columbus Barber founded Barberton in 1891 over a tax dispute with the City of Akron, where he had operated his Diamond Match Company along the Upper Basin. The town's growth was so rapid that it became the "Magic City." Barberton eventually supplanted the earlier canal communities of New Portage and Wolf Creek. Besides matches, Barber also shipped produce, salt, strawboard, steel, and tile along the canal. The Carrara Paint Company (above), one of Barberton's many manufacturing plants, was located beside Lock 1 at the southern boundary of the nine-mile-long Portage Summit level. Even though Barberton is heavily industrialized, there was once a swimming hole on the canal here (below). (Above, courtesy of Dave Neuhardt; below, UA-Baus.)

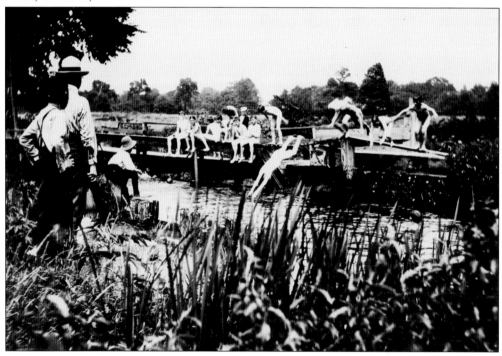

Three

UPPER TUSCARAWAS VALLEY

From Lock 1 (south) at Barberton, the Ohio and Erie Canal descended down the Tuscarawas Valley. Locks 2 and 3 were located at Clinton, where a dam and guard lock supplemented the water supply. Other feeder systems in the Upper Tuscarawas Valley section included those at Nimisilla Creek, Mud Brook, Sippo Creek, and Sugar Creek. Elevation changes were minimal in modern Stark County, so only three lift locks were originally constructed here: Lock 4 at Canal Fulton, Lock 5 at Massillon, and Lock 6 at Navarre. Near the Stark-Tuscarawas County Line, the canal crossed the Tuscarawas River over a large aqueduct near Bolivar. There was another aqueduct over Wolf Creek near Barberton.

The short-lived Sandy and Beaver Canal intersected with the Ohio and Erie Canal at Bolivar and later served as a feeder. Between Bolivar and the German separatist community of Zoar, where a short feeder and sidecut canal provided access, were four closely spaced locks (Locks 7 to 10). Next in line were two more locks (Locks 11 and 12), the canal collector's office at Dover, and the crossing of Sugar Creek. The main line of the Ohio and Erie Canal did not pass through New Philadelphia, but the town was connected via a short lateral canal behind a milldam. Lock 13 was at Southside (opposite New Philadelphia), and Lock 14 was near Goshen.

Towns along the Ohio and Erie Canal on the 54-mile-long Upper Tuscarawas Valley section include Clinton, Canal Fulton, Massillon, Navarre, Bolivar, Zoar, Dover, Southside (New Philadelphia), Oldtown, New Castle, and Goshen.

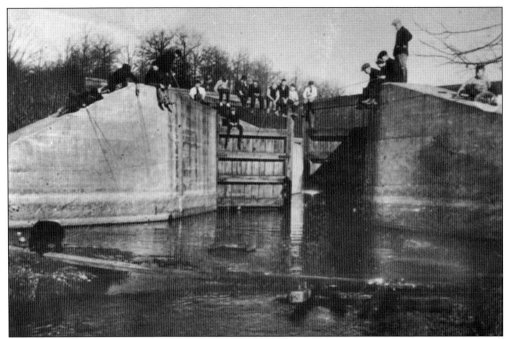

Except for Lock 29 at Peninsula, all of the 60 locks from Cleveland to Trenton in Tuscarawas County were reconstructed out of concrete between 1905 and 1909. This includes Lock 2 (above) at Clinton. Boys play with their boat *Teddy* in the concrete chamber of Lock 3 (below), with Lock 2 in the background. Between these locks was a boat slip for loading coal from the Rogues Hollow area. Because the canal crossed the Tuscarawas River at Clinton, a change bridge at Lock 3 kept the towpath between the river and canal. The below photograph was taken from this change bridge, which still exists. Clinton is named for the "Father of the Erie Canal," New York governor DeWitt Clinton. (Above, courtesy of Massillon Museum; below, CSO.)

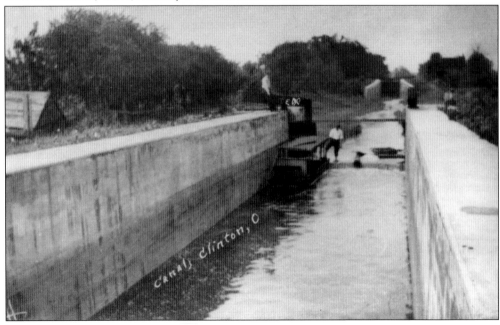

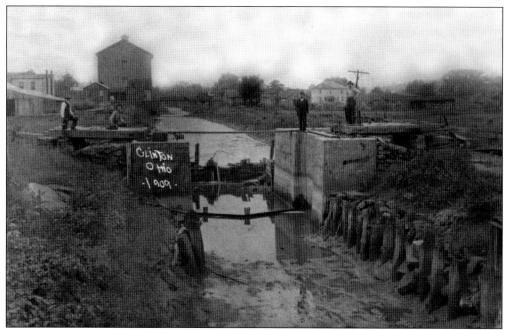

Guard locks, typically located near slackwater crossings, protected or "guarded" the canal from high water. Taken in 1909 after reconstruction, this photograph of the guard lock looks south toward the Clinton Roller Mills. This mill was destroyed on the night of July 4-5, 1909, by a fire started by a smoldering firework. (Courtesy of Dave Meyer.)

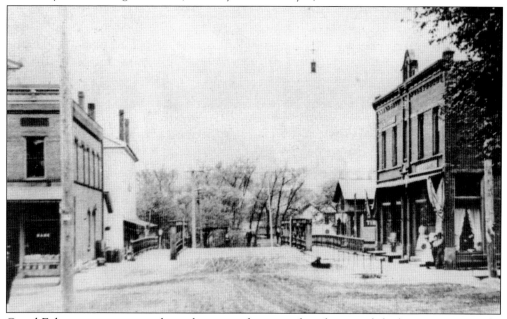

Canal Fulton, a quintessential canal town, is shown in this photograph looking west across the canal from Public Square. The town was platted in 1826. Taverns at each corner of Canal and Cherry Streets generated the town's roughneck nickname "Brimstone Corners." Tamer today, Canal Fulton recognizes its heritage by hosting an Olde Canal Days Festival every July. It is also the embarkation point for the *St. Helena III*. (Courtesy of Canal Fulton Library.)

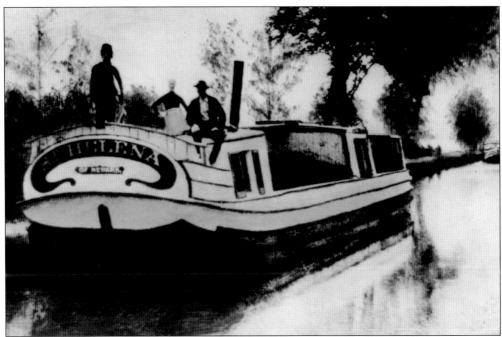

Originally registered at Newark, the *St. Helena* (above) is now undeniably associated with Canal Fulton. With renewed interest in canals in the 1960s, citizens of Canal Fulton constructed the *St. Helena II*. After its wood hull rotted beyond repair, the concrete-bottomed *St. Helena III* was built. This boat is one of only two still operating along the Ohio and Erie Canal. The other one is the *Monticello III* at Coshocton. During winter months, the *St. Helena III* is stored in McLaughlin's dry dock. Below, Willie McLaughlin, 80, stands in the foreground in the chamber of Lock 4. His family operated the dry dock during the canal era. McLaughlin was a former canal boatman who assisted on a 1938 Works Progress Administration job to create Ohio's first canal park. (Both, CSO.)

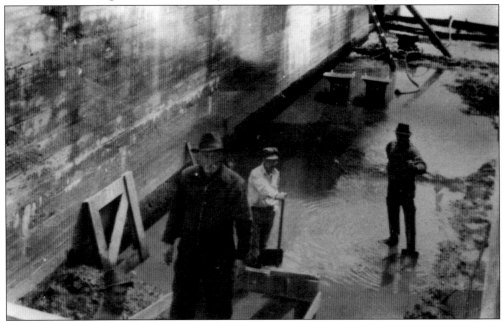

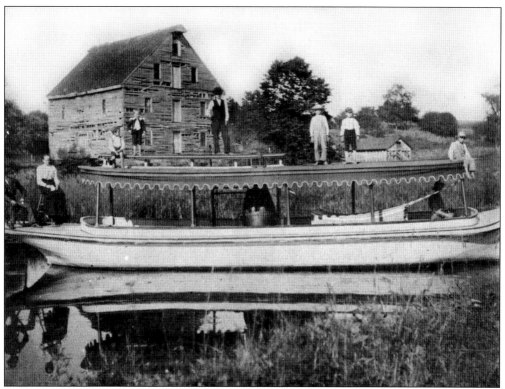

Willie McLaughlin's family also ran this curious-looking steamboat. Not a commercial vessel, it was used for pleasure rides only. In the background is the Fenelon Mill, which operated along the Lock 4 spillway. Established by Massillon founder James Duncan in the 1830s, it changed hands several times before closing in 1902. It was torn down in 1908. (Courtesy of Canal Fulton Library.)

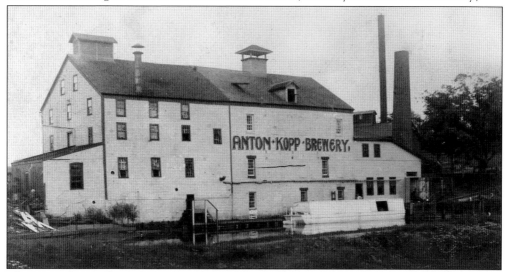

The gristmill at Millport (now Crystal Springs) was converted into a brewery in 1883. It was run by Anton Kopp from 1894 to 1898. Beer boats shuttled along the canal from the brewery to the bottling plant in Massillon. John Schuster purchased the brewery from Kopp and moved it to Massillon in 1901. (Courtesy of Massillon Museum.)

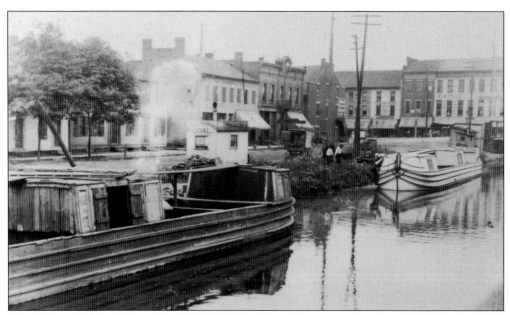

Entrepreneur James Duncan founded Massillon along the proposed route of the Ohio and Erie Canal in 1826. He named the town after French Catholic bishop Jean-Baptiste Massillon. The town grew quickly, absorbing the earlier community of Kendal, with Duncan as its prime mover and shaker. Duncan and his partners not only built the canal at Massillon, he convinced the state to let him construct a feeder on Sippo Creek to supply his Massillon Rolling Mills consortium. The Sippo feeder dam was breached in February 1848, resulting in considerable property damage. Fortunately, nobody was killed. Duncan was also a toll collector. Canal Street (now First Street) followed the canal towpath through Massillon. In the above photograph, cargo boats are docked at Massillon's public landing on Canal Street. Below, a line of boats awaits loading beside the towpath. (Both, courtesy of Massillon Museum.)

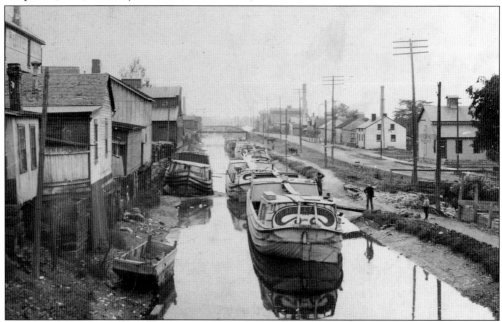

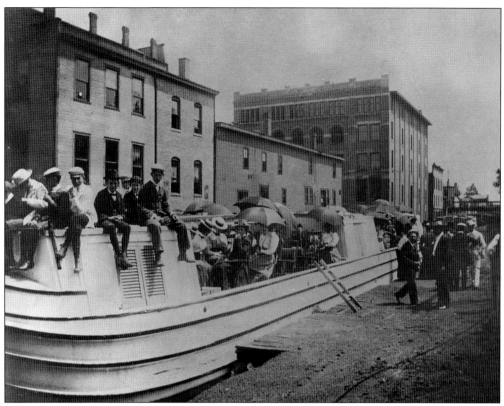

Members of a Presbyterian church board a canal boat for a picnic outing at the public landing in Massillon. The landing was located between Main Street (now Lincoln Way) and Tremont Street. In the right background is the McLain Warehouse Grocery Company Building. (Courtesy of Massillon Museum.)

So much wheat was shipped through Massillon that it was called "Wheat City." As many as 14 warehouses once lined the canal here. Shown here is the *Northdell* at the Wellman/ Atwater Warehouse on Main Street. Fred Hoffman sold this boat to Perry Hanlon in 1889. Massillon eventually evolved from a canal port into a manufacturing center, becoming a steel town. (Courtesy of Massillon Museum.)

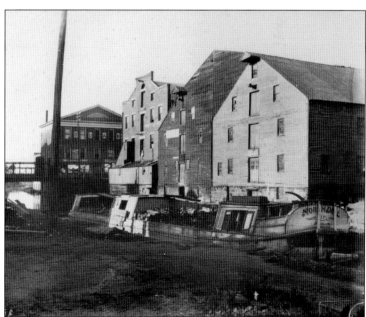

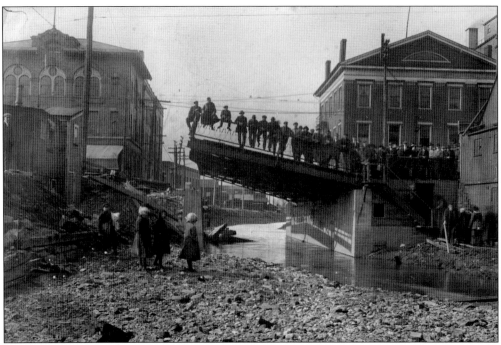

Crowds gather at the Main Street lift bridge over the canal in the aftermath of the 1913 flood. The flood led to the formation of the Massillon Conservancy District, which moved the Tuscarawas River in the 1940s. Further river improvements, highway construction, and sewer projects completely obliterated all traces of the canal at Massillon. (Courtesy of Massillon Museum.)

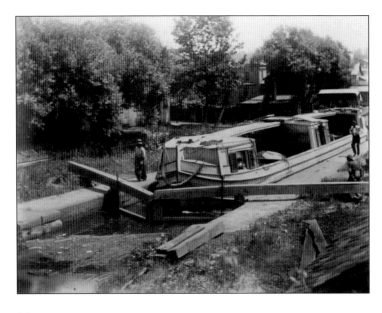

Thanks to James Duncan, there were three Lock 5s at Massillon. Shown here is Lock 5 at Walnut Street, built in 1839 when the Massillon Rolling Mills straightened the canal. The original Lock 5, a short distance south, then became Lock 5A, which was in turn removed by the state in 1909 and replaced with another lock farther south, New Lock 5A. (Courtesy of Massillon Museum.)

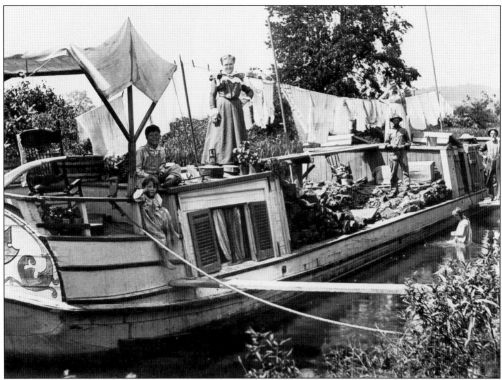

Mothers were the unsung heroes of canal boats. In addition to doing laundry and preparing meals, their responsibilities included raising and teaching children. Canal children received very little formal education, and they had chores of their own, such as tending to animals. Families lived year-round in an approximately 12-foot-by-12-foot room at the stern of the boat. (UA-Baus.)

There is a well-known photograph of three cargo boats from Drago Hill near Navarre, with the Tuscarawas River in the background. A more interesting perspective is provided in this photograph, taken from the canal, looking back up the hillside. Canal workers first inhabited this neighborhood, later named Little Italy for an influx of immigrants, to work the local mines. (Courtesy of Massillon Museum.)

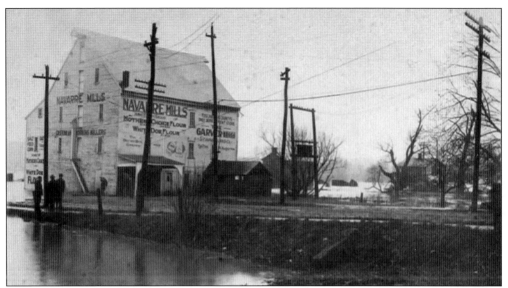

Navarre is a combination of three communities. Bethlehem came first, founded in 1806 by Jonathan Condy as a religious community. Rochester was second, laid out along the canal by Nathan McGrew in 1833. Ever the opportunist, James Duncan established his village of Navarre between Bethlehem and Rochester in 1834. Duncan's Navarre Mills (above) operated along the Lock 6 spillway. Members of the Dayley Brothers Construction Company pose at Lock 6 in 1907 (below). While this contractor rebuilt only about a dozen structures, Dayley Brothers has become synonymous with the effort to reconstruct the Ohio and Erie Canal from 1905 to 1909. Perhaps this is because the company left its name on every project, as seen in the below photograph. (Above, courtesy of Massillon Museum; below, CSO.)

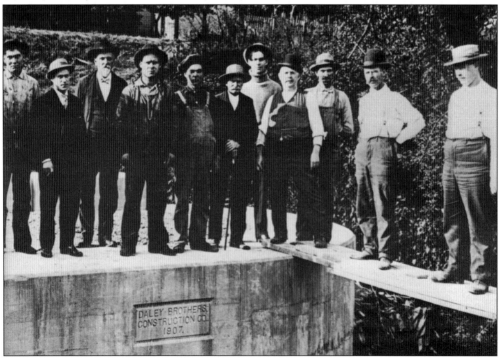

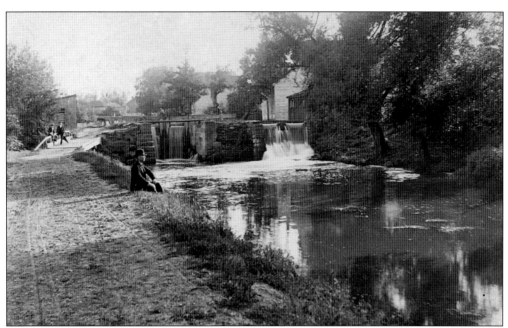

William Bennett was a prolific canal photographer from Navarre who exchanged images with Louis Baus. Baus's collection resides at the University of Akron, while Bennett donated his photographs to the Massillon Museum in the 1930s. Views of Lock 6 (above) and the state boat *Lybarger* in the lock chamber (below) represent a sampling of Bennett's work, which numbered over 2,000 photographs. Lock 6 has since been incorporated into the loading dock of a bakery. No discussion of Navarre would be complete without mentioning Ralph Regula. Getting his start in politics as Navarre's town recorder, Regula's canal walks in the 1960s sparked interest in the Ohio and Erie Canal. Later, as a congressman, he was instrumental in creating the Ohio and Erie Canalway and Cuyahoga Valley National Park. (Both, courtesy of Massillon Museum.)

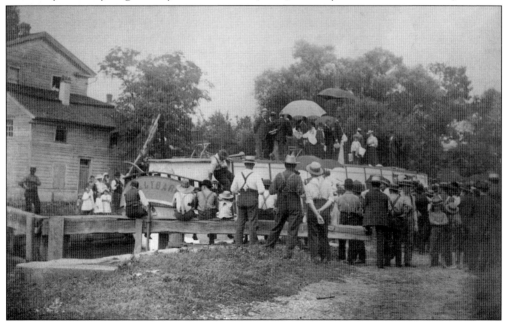

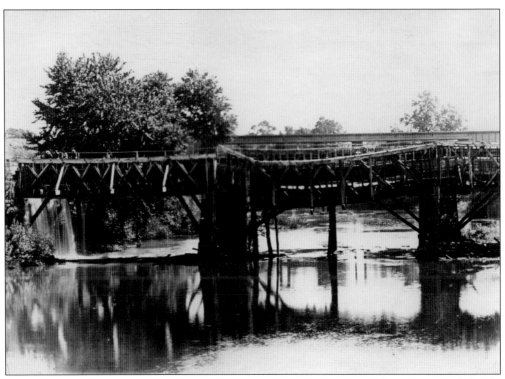

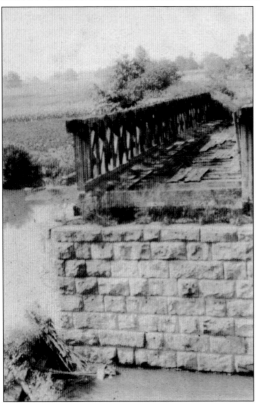

Between Locks 6 and 7 was a 10-mile level in southern Stark County and northern Tuscarawas County. Highlights of this section included Wildcat Basin and the Big Willow Hotel, which was a relay station for horses during the passenger packet era, which ended around 1852. Mule driver Hank Keck was reportedly attacked by a wildcat here, but he was saved from a serious mauling when the animal was hurled into the canal. At the county line was the Great Tuscarawas or Bolivar Aqueduct, shown with considerable sag (above). The photograph to the left shows the aqueduct after the trunk had fallen into the river in 1921. The piers and abutments of this 160-foot-long structure remained in sufficiently good condition that a bridge for the Ralph Regula Towpath Trail was placed across the aqueduct foundation in 2013. (Both, CSO.)

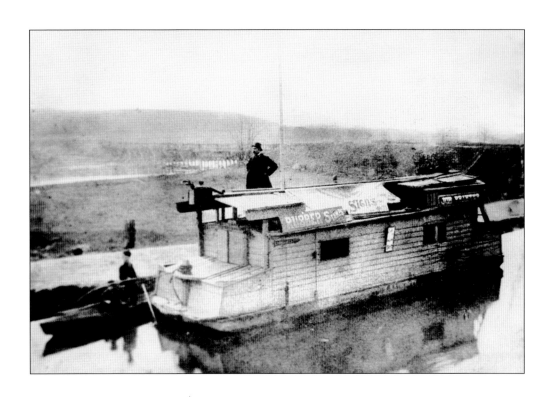

There were two canal aqueducts at Bolivar, but the second one was on the Sandy and Beaver Canal. This 73-mile-long canal ran from Bolivar to Glasgow, Pennsylvania. Operating only from 1848 to 1852, the westernmost six miles of the Sandy and Beaver Canal were acquired by the state in 1856 and maintained as a feeder for the Ohio and Erie Canal until the aqueduct collapsed in 1883. It may be seen just behind the head of the man standing in the merchant boat in the above photograph. Later, the remaining stub of the Sandy and Beaver Canal at Bolivar was used as a dry dock (below). Construction of Interstate 77 in the 1960s wiped out nearly all traces of both canals at Bolivar. (Both, UA-Baus.)

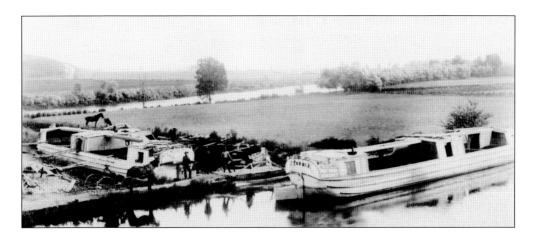

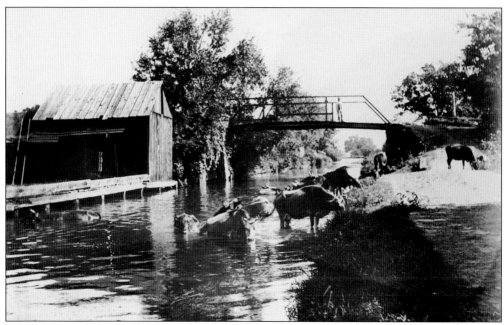

Cows cool off in the canal near the Poplar Street Bridge at Bolivar. Originally called Kelleyville in honor of canal commissioner Alfred Kelley, the town was renamed for South American revolutionary Simón Bolívar. (Ohioans pronounce the name to rhyme with Oliver.) The canal cut through the eastern ramparts of nearby Fort Laurens, a Revolutionary War fort from 1778 to 1779. (UA-Baus.)

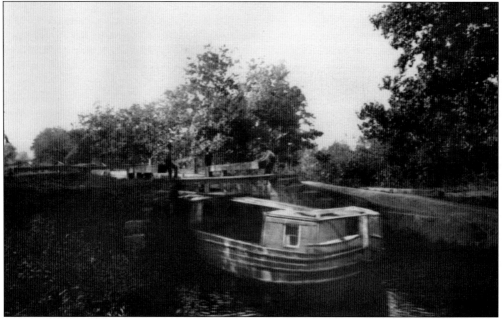

There are four extant canal locks between Bolivar and Zoar (Locks 7 to 10) bearing the Dayley Brothers Construction logo. Here, a boat passes through one of these locks, most likely Lock 10. Lock 10 was originally constructed by the Zoar separatist community, which operated a fleet of boats along the canal. (CSO.)

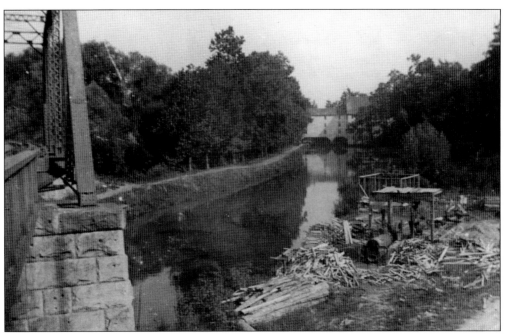

Zoar was a communal society founded in 1817 by a German sect escaping religious persecution. The arrival of the canal ushered in a period of economic prosperity for the community, which was led by Joseph Bimeler. Near the railroad bridge (above) was a short feeder that provided access to Zoar across the river behind a typical V-shaped dam. An inscription bearing the year 1830 can still be read on the guard lock at Zoar. Visible in the distance is the six-story Zoar Flouring Mill. Note that the mill was built across the canal, allowing boats to be loaded directly. The loading dock had been removed by 1912, as seen below, and the mill was torn down in 1920. The state once operated a fish hatchery in the canal at Zoar, but this ceased operations in 1935. (Above, UA-Baus; below, CSO.)

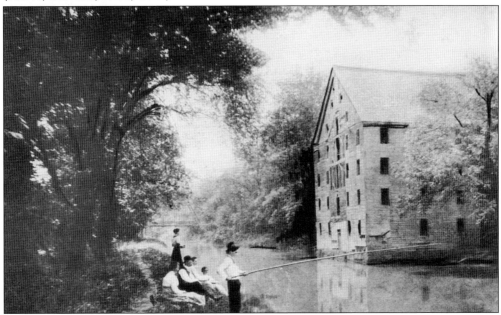

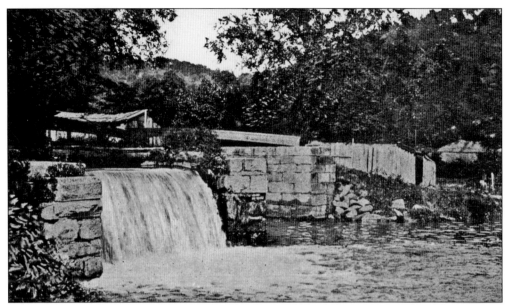

Lock 11, or Quarry Lock, still sits along Ohio Route 800, about a mile south of Dover Dam. A log-cabin restaurant atop the lock characterized Lock 11 for years, but this structure has been removed. This period postcard of the lock is titled "Ohio Canal, Cleveland, O.," a glaring misattribution. (CSO.)

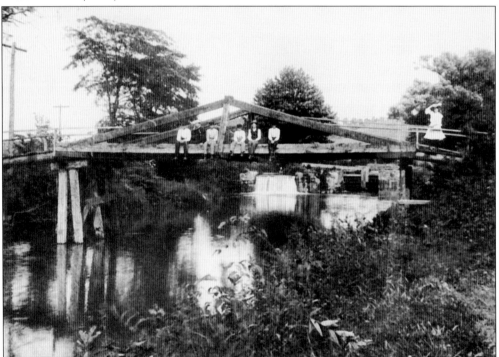

Another lock was situated along Ohio Route 800 north of Dover, but it is no longer there. This is Lock 12, or Jones Lock. A property owner living in the lock tender's house in the 1930s grew tired of hauling coal in a wheelbarrow across the rickety bridge over the lock chamber, so he told his wife, "Let's blow that sucker up and fill it with dirt!" (UA-Baus.)

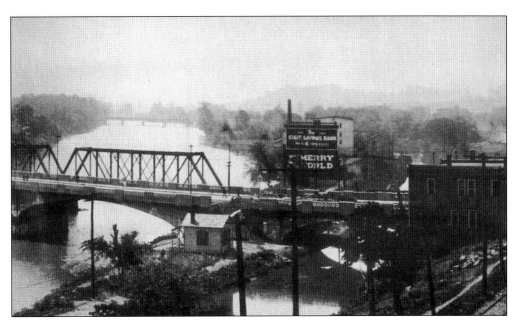

Marylanders Christian Deardorff and Jesse Slingluff founded Dover in 1807. The village struggled until the canal arrived 22 years later. Officially known as Canal Dover from 1842 to 1915, Dover constructed a hydraulic race to power its mills. Iron and steel were the focus of later industrial growth. There were 13 tollhouses along the length of the Ohio and Erie Canal, and one of these was located at Dover. The Dover tollhouse, seen at left foreground in the above photograph, was between the canal and the river at Factory Street (now Tuscarawas Avenue). Looking south, the distant railroad bridge across the Tuscarawas River was at the mouth of Sugar Creek. The towpath crossed Sugar Creek over a footbridge (below), with the canal in slackwater behind a dam. (Above, courtesy of Dave Meyer; below, CSO.)

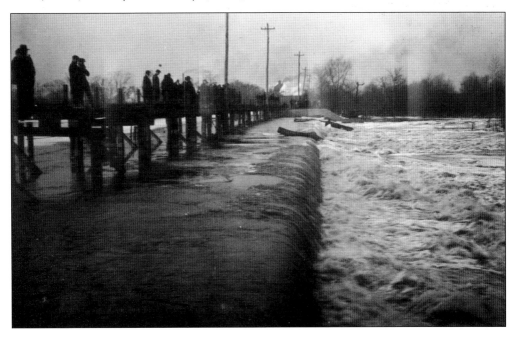

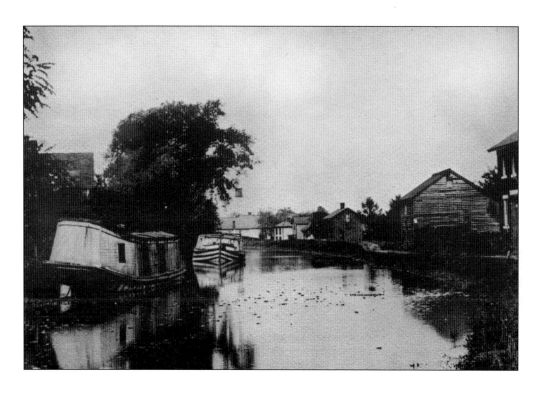

When Tuscarawas County was organized in 1808, Dover and New Philadelphia were rivals for the county seat. New Philadelphia won this bloodless "Courthouse War," but it lost an equally important battle years later, when the Ohio and Erie Canal was routed on the opposite side of the Tuscarawas River, through Dover and bypassing New Philadelphia. Construction of a lateral canal in 1837 provided New Philadelphia direct access to the Ohio and Erie Canal. Pennsylvanian John Knisley founded New Philadelphia in 1803 near David Zeisberger's Moravian missionary village of Schoenbrunn. The main line of the canal ran through Southside. Both of these photographs look west toward Broadway Street from Lock 13. The stereoscopic image of the lock dates to before 1907, as the lock chamber is constructed of stone. (Above, CSO; below, UA-Baus.)

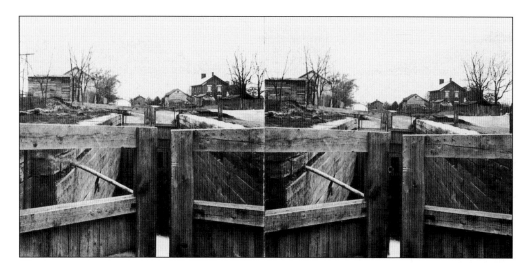

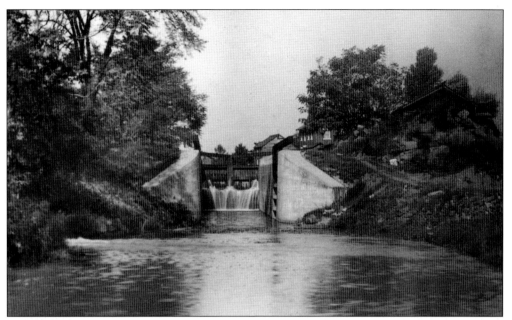

Lock 13 is seen in the above photograph, taken sometime after the lock was rebuilt with concrete in 1907. This lock was the site of Walter Blake's mill, built in 1850, closed in 1949, and razed in 1995. A county sheriff and canal contractor, Blake platted Blakesfield at the lock and mill site. Lockport was immediately adjacent to Blakesfield. Together, the two communities were generally known as Southside, which was eventually absorbed into New Philadelphia. Southside was home to at least a dozen canal-boat captains, many of whom tied up here during the winter months. One of these was Jonathan Niermeyer, shown below at the tiller of the *River Mills*. Another New Philadelphia canal boat was the *Sassykanudrop*, a celebrated party boat. (Above, CSO; below, UA-Baus.)

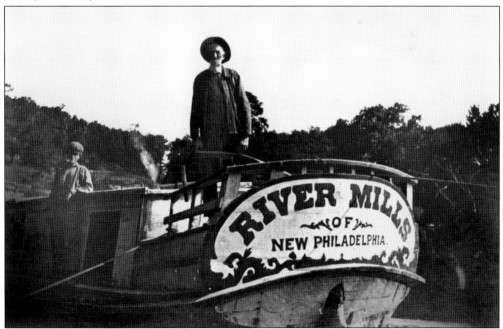

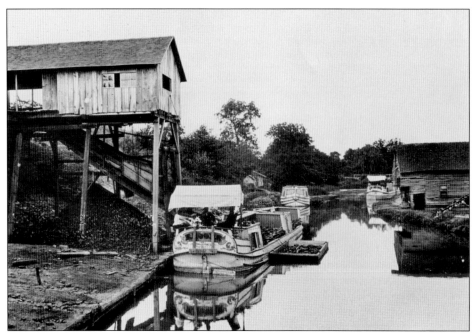

Goshen Township, in central Tuscarawas County, was a rich coal-mining region, led by the Tuscarawas Valley Coal Company and Brock Hill Coal Company. Tipples for loading coal onto canal-boat freighters were located at Oldtown, New Castle (Lock 14), and Goshen (burial site of Moravian missionary David Zeisberger). Minnick's Coal Chute (above) was one such facility. In the photograph, the *E. Moore* of Chillicothe takes on a load. Below, a mother holds her infant on the roof of a canal boat loaded with coal. This is one of the more emotionally moving photographs ever taken on the Ohio and Erie Canal. (Above, CSO; below, UA-Baus.)

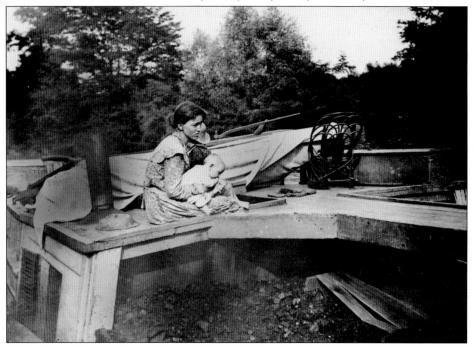

Four

LOWER TUSCARAWAS AND MUSKINGUM VALLEYS

Beginning at Trenton (now Tuscarawas), the Ohio and Erie Canal picked up water from a three-mile-long navigable feeder, which allowed boats to travel as far as Uhrichsville. From Locks 15 and 16 at Trenton, the canal continued its descent in the Tuscarawas Valley to Seventeen, a village named after Lock 17. More locks dropped the canal through Port Washington (Lock 18) and Newcomerstown (Lock 21). Entering Coshocton County, four locks (Locks 22 to 25) were located between Newcomerstown and Canal Lewisville. The canal crossed Evans Creek over a short aqueduct at Orange.

Roscoe is situated at the confluence of the Tuscarawas and Walhonding Rivers. Canal features at Roscoe include three large basins, an aqueduct across the Walhonding, a double lock (Locks 26 and 27), a tollhouse, and the junction of the Walhonding Canal. This canal supplied the Ohio and Erie with water from a dam six miles above the junction, and it entered Roscoe's Lower Basin via a set of triple locks. Below Roscoe, the Ohio and Erie Canal continued along the Muskingum River to Adams Mills, where three locks (Locks 28 to 30) dropped the canal to its lowest level between the two summits. A sidecut canal at Dresden provided access to the Muskingum. There was also a toll collector's office at Dresden.

Towns along the Ohio and Erie Canal on the 49-mile-long Lower Tuscarawas and Muskingum Valleys section include Tuscarawas (Trenton), Seventeen, Port Washington, Glasgow, Newcomerstown, Orange, Canal Lewisville, Roscoe, Tyndall, Conesville, Adams Mills, and Dresden.

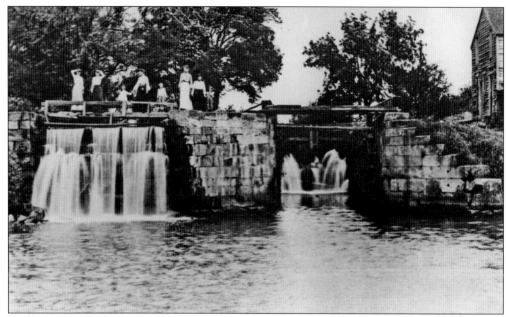

Predating the canal, Trenton was founded in 1816 by Abraham Ricksecker and Abraham Romig. The name of the village was changed to Tuscarawas in 1889. There were two locks here, Lock 15 (Upper Trenton Lock) and Lock 16 (Lower Trenton Lock). Lock 15 (pictured) is now the centerpiece of a roadside park. (CSO.)

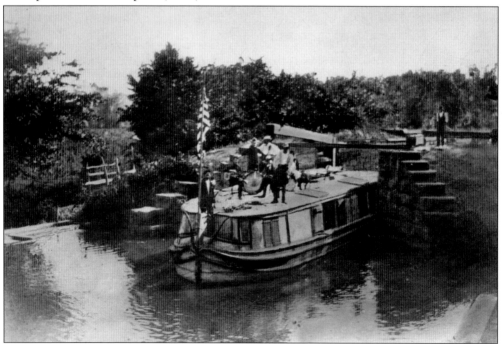

A brass band plays as the *Valley Mills* exits Lock 16. This was the southernmost lock on the canal to be rebuilt with concrete. A navigable three-mile-long feeder entered a large basin just below Lock 16. Water was supplied to the feeder by a dam on the Tuscarawas River near the mouth of Stillwater Creek, which was navigable to Uhrichsville. (CSO.)

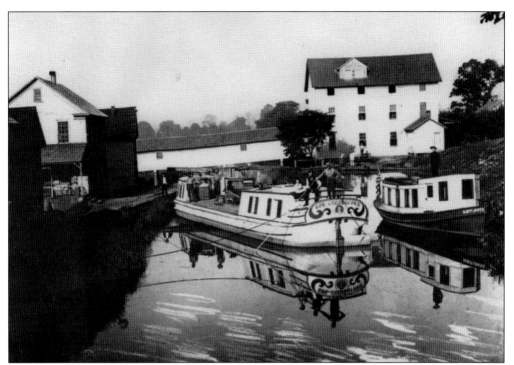

Seventeen, Ohio, derives its name from the number of the canal lock here. Lock 17 is gone, a casualty of the construction for US Route 36, but the main building of the Buckeye Roller Mills remains. The smaller boat at the right of the photograph is the *Mayflower*, a popular local excursion boat. Seventeen occupies the site of a Moravian missionary settlement, Beersheba. Gnadenhutten is across the river. (CSO.)

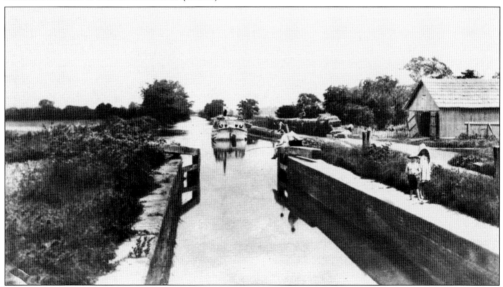

Ohio's first state road was completed in 1833, connecting Millersburg in Holmes County to Port Washington on the Ohio and Erie Canal. The road made the area a hub for grain trade. Lock 18 (pictured) was about a mile northeast of Port Washington. Below the town was the failed 1870s industrial venture of Glasgow Furnace. (UA-Baus.)

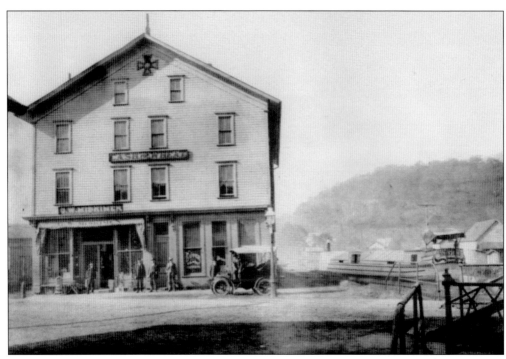

Netawates, or Chief Newcomer, established the Delaware capital of Gekelemukpechunk here in 1764, and it was platted as Newcomerstown in 1827. During the canal era, Newcomerstown's commercial activities were focused around the Miskimen General Store (above). A surviving relic from the 19th century, it is now the Eureka-Orme Hardware Store. There were once four hotels in Newcomerstown (Commercial, Fountain, Globe, and Central) in addition to several mills, an iron foundry, a potter's shop, a tannery, a blacksmith shop, a newspaper, and no less than five saloons. The Emerson & Son Mill (below), a replacement for the Wiandt Mill, which burned down in 1872, operated at Lock 21. It is now gone, although some stones might have been incorporated into a nearby house foundation. (Both, CSO.)

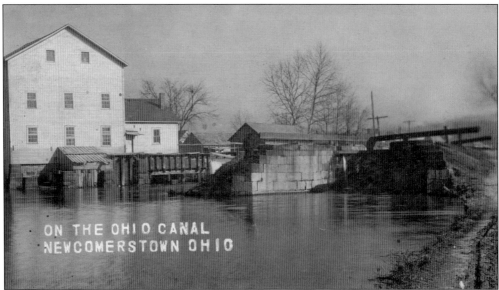

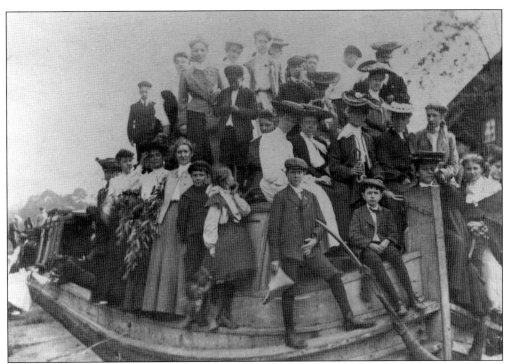

This photograph is believed to depict an outing of the Methodist Episcopal Sunday school of Newcomerstown on the excursion boat *Akron*, owned by Frank Lyons. The date is July 4, 1885, and the location is Orange, also known as Evansburg. The canal crossed a short aqueduct over Evans Creek at Orange. The boat would have passed through Lock 22 and Lock 23 on its short journey. (RVF.)

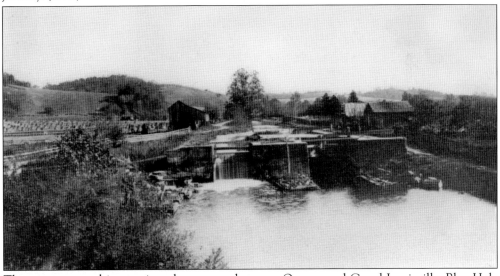

There were several interesting place-names between Orange and Canal Lewisville. Blue Hole Lock was the common name for Lock 24. Called Unusual Junction today, this area was also the site of preeminent canal historian Ted Findley's Camp Aw-Go-On. Next came a double culvert with 18-foot twin arches over White Eyes Creek. All of these structures are gone, but Lock 25, or Wild Turkey Lock, shown here, remains. (CSO.)

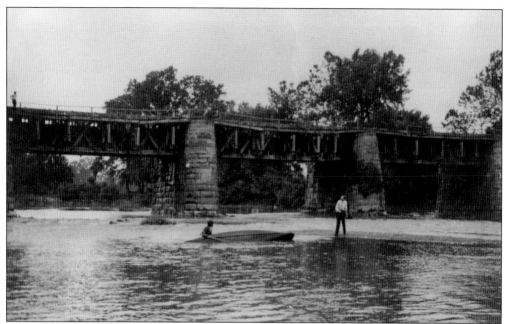

Coming into Roscoe, the Ohio and Erie Canal passed through three large basins (Upper or Mudport, Middle, and Lower or Roscoe), a double lock (Locks 26 and 27), and an aqueduct over the Walhonding River. Derived from the Native American word for "white woman," the Walhonding joins the Tuscarawas just below the aqueduct (pictured) to form the Muskingum River. (CSO.)

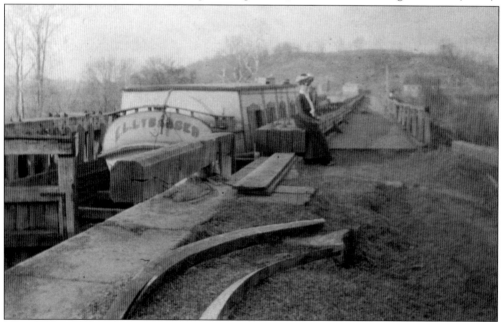

The state boat *Lybarger*, also photographed by William Bennett at Navarre (see page 59), sits in the wooden flume of the Walhonding Aqueduct at Roscoe. Gates of Lock 26 are in the foreground, and the towpath is at right. Today, the *Monticello III* canal boat operates in Coshocton's Lake Park between the Upper and Middle Basins, while the *Caldersburg Pearl* is dry-docked at Roscoe Village. (RVF.)

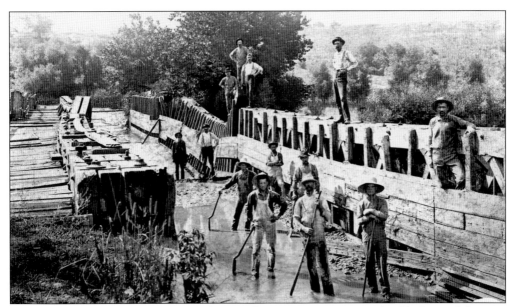

Aqueducts were a maintenance headache, usually requiring a major overhaul before each boating season. These structures were essentially wooden troughs held together by iron bolts. Supported by abutments at each end and resting on piers, aqueducts were required to hold tremendous amounts of water. They were rarely watertight and frequently leaked. Here, a repair crew fixes the Walhonding Aqueduct. (CSO.)

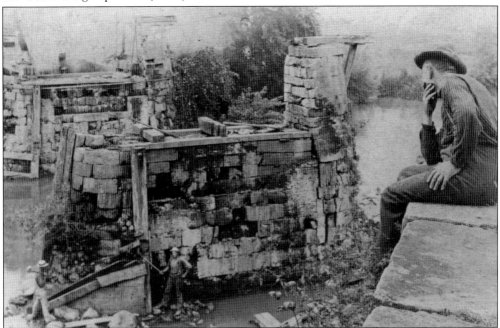

Sometimes, wooden aqueducts were completely destroyed by flooding or ice floes. This is the Walhonding Aqueduct after one such event. This aqueduct would eventually be "repaired" in 1976, when a wooden footbridge was constructed across the original abutments. The second-longest aqueduct on the Ohio and Erie Canal, the Walhonding Aqueduct was 310 feet long and required four piers. (CSO.)

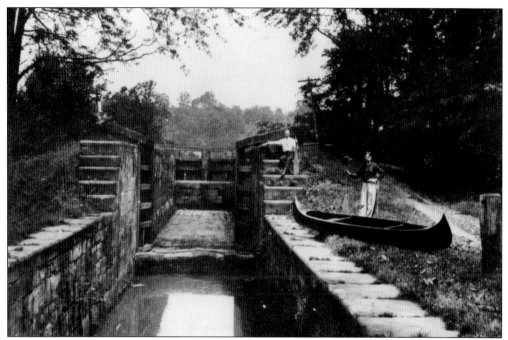

A canoeist poses on the towpath at Locks 26 (rear) and 27 (front). This was a double lock, with the lower gates of Lock 26 also serving as the upper gates for Lock 27. The gate between the locks is open in this photograph, with the Walhonding Aqueduct directly behind the closed upper gates of Lock 26. (CSO.)

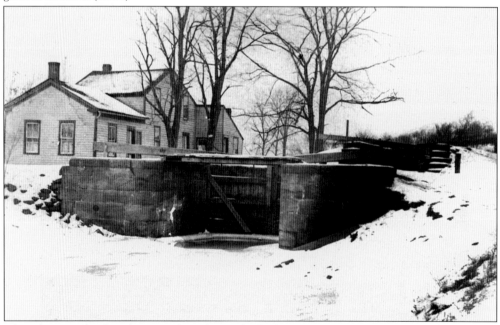

This photograph of Locks 26 and 27 shows the lock tender's house during winter. When the footbridge was built over the old aqueduct in 1976, Lock 26 had become so damaged by tree roots that many of the stones had to be removed. Pearl Nye later constructed his Camp Charming at these locks. (UA-Baus.)

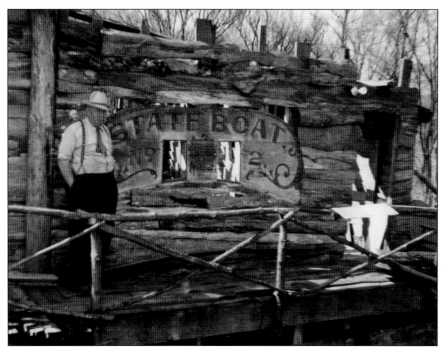

Pearl Nye was born on the canal boat *Reform* at Chillicothe in 1872, the 15th of 18 children. Until 1913, he spent his entire life living and working along the canal on the Nye family boats *Warren* and *Tom Marfield*. About 1929, he began construction of his Camp Charming home from the state boat *Rosalie* at the Roscoe double locks, and he spent the remainder of his life collecting songs and preserving the folklore of the canals. Nye, shown in these two photographs, was the self-described "last of the canal boat captains." Recordings of his songs have been preserved by the Library of Congress. Nye, who lived at Camp Charming in the 1930s and 1940s, attended National Folk Festivals in 1938, 1942, and 1946. The "bard of the Ohio and Erie Canal" died in 1950. (Both, RVF.)

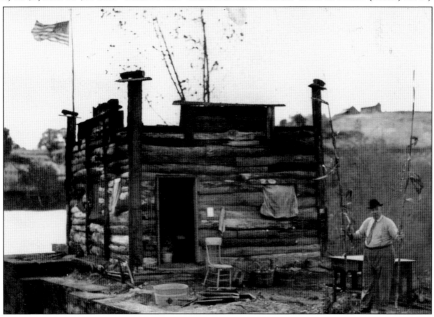

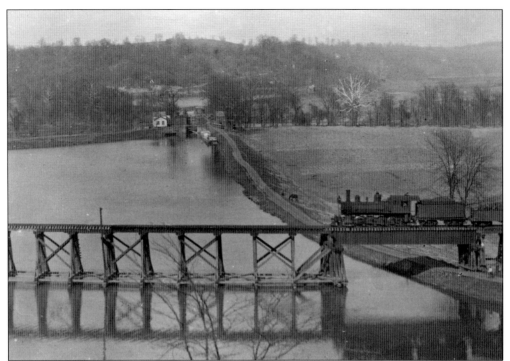

Seen here crossing the Lower Basin at Roscoe is the *Wally Flyer* locomotive on the Toledo, Walhonding Valley & Ohio Railroad. Pilings from the trestle, and the basin itself, remain. From this panoramic perspective, Locks 26 and 27 and the lock tender's house may be seen in the background, at the end of the basin. The towpath passes under the train and heads toward the locks. (RVF.)

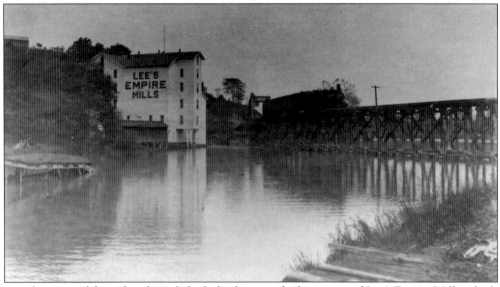

Another view of the railroad trestle looks back across the basin toward Lee's Empire Mills, which sat at the outlet of the Walhonding Canal. Derided as a "canal to nowhere," the Walhonding Canal was 25 miles long and emptied into Roscoe Basin through a set of triple locks. These are preserved in a small roadside park. (RVF.)

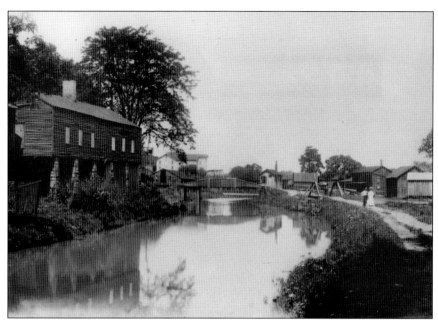

Roscoe was founded as Caldersburg in 1816 by Coshocton businessman James Calder. The town was renamed Roscoe in 1831 to honor English abolitionist William Roscoe. It experienced the typical boom-and-bust cycle of most canal towns and had almost been completely forgotten by 1968, when Edward and Frances Montgomery led a restoration effort that resulted in Roscoe Village. These photographs feature the Roscoe tollhouse, which has been fully restored. Other historic buildings include a craftsman's home, cooperage and printer's shop, doctor's house, general store, school, smithery, and a warehouse that now operates as a restaurant. There is also a museum in the visitor center. With the aqueduct, canal-boat ride, double locks, triple locks, and watered basins, Roscoe Village should be visited by anyone with even a passing interest in canal history. (Both, CSO.)

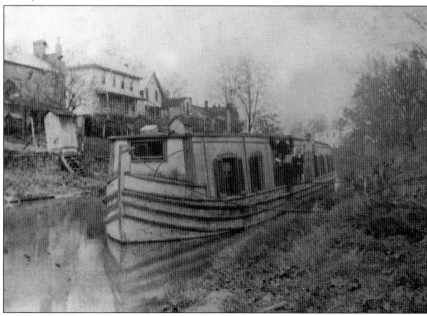

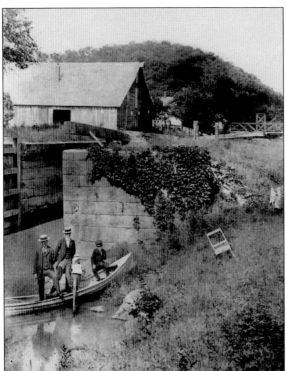

Ohio Route 16 fills the canal bed below Roscoe through the villages of Tyndall and Conesville. At Adams Mills, three locks dropped the canal to its lowest level between the Portage and Licking Summits. Lock 29 is pictured here. The village grew up around the Adams Brothers Flouring Mills. Nearby, Munroe Basin is a surviving watered remnant of the canal. (Courtesy of Dave Meyer.)

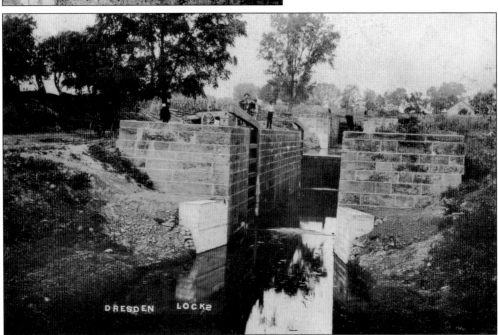

Three more locks dropped the Ohio and Erie Canal into the Muskingum River at Dresden. These locks were located on the Dresden, or Muskingum Sidecut, Canal, a connecting spur between the river and main canal. The 29-foot fall from these locks once powered Rambo Mills. Dresden, which predates the canal by several years, was established at the Native American village site of Wakatomika. (Courtesy of Dave Neuhardt.)

Five

LICKING VALLEY
AND SUMMIT

Climbing from Dresden, the Ohio and Erie Canal began its ascent at Webbsport (Locks 18 and 19) toward the Licking Summit level. At Frazeysburg were two more lift locks (Locks 16 and 17) and an aqueduct over Wakatomika Creek before the canal squeezed into the Licking Narrows. Exiting the narrows at Lock 15, there were several more lift locks (Locks 10 to 14) before the canal crossed the North Fork of the Licking River and entered Newark proper at Lock 9. Newark was also the site of a tollhouse. Another aqueduct over Raccoon Creek and four more lift locks (Locks 5 to 8) were on the west side of Newark. This was the formerly independent community of Lockport. After passing the fairgrounds at Lock 4, three more locks (Locks 1 to 3) raised the canal to the Licking Summit level. This is where New York governor DeWitt Clinton broke ground on the Ohio and Erie Canal on July 4, 1825.

Besides the dam at the Licking Narrows, water was also provided to the canal by the North Fork Feeder, Kirkersville Feeder, Granville Feeder (which was navigable), and the Licking Summit Reservoir (Buckeye Lake). The summit level was originally 14 miles long, but when the level of the Licking Summit Reservoir was later raised, it was shortened to four miles. This also necessitated the construction of two locks: Minthorn's at the northern end and Pugh's at the southern end. There were also two short aqueducts on the summit level, over Lake Run and South Fork.

Towns along the Ohio and Erie Canal on the 44-mile-long Licking Valley and Summit section include Webbsport, Frazeysburg, Nashport, Hanover, Marne, Swans, Newark, Lockport, Heath, Hebron, and Millersport.

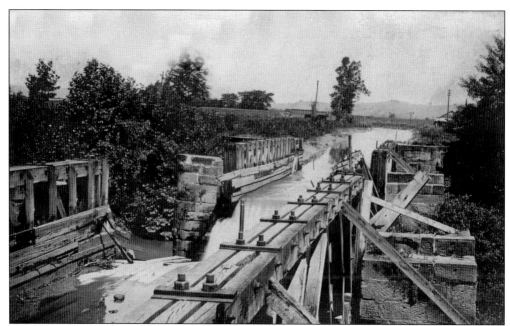

At Webbsport, the Ohio and Erie Canal began its ascent toward the Licking Summit via Locks 18 and 19. The canal crossed Wakatomika Creek over aqueducts at both Dresden on the sidecut (pictured) and the main line at Frazeysburg. Locks 16 and 17 were at Frazeysburg, founded by speculator Samuel Frazey in 1828. (Courtesy of Dave Neuhardt.)

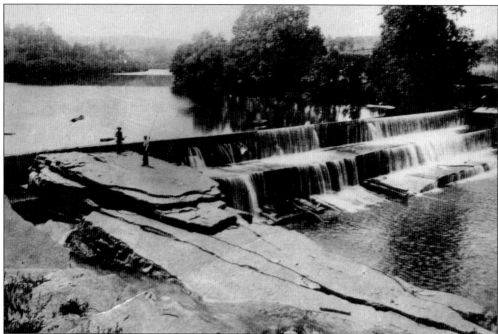

The Licking Narrows dam was characteristic of those built to supply water to the canal but geography presented a difficult problem for canal engineers at this location. Upstream from this dam, the Licking Valley squeezes into a narrow gorge without any space to dig a canal. This area is now the Blackhand Gorge State Nature Preserve. (CSO.)

To resolve the navigation problem of the Licking Narrows, a guard lock was constructed. This allowed boats to pass into the river. A towpath was blasted out of sandstone, destroying an ancient painting of a black hand on the gorge wall. The arrangement allowed boats to be pulled through the river for a distance of two miles between the dam and Lock 15. (RVF.)

Rather than aqueducts, which were expensive and difficult to maintain, the canal crossed smaller streams via stone culverts. These underappreciated structures are not extensively documented. No photograph of an Ohio and Erie Canal culvert from the operating era is known to exist. This is the impressive double-arch Rocky Fork Culvert near Lock 14 at Hanover in 1970. (CSO.)

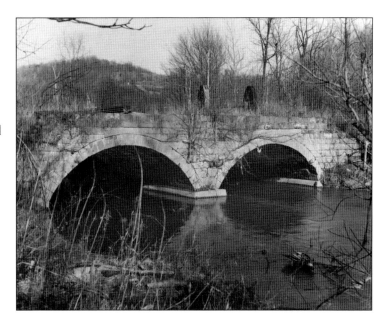

From Hanover, the canal passed through Lock 13 at Marne, Locks 11 and 12 at Swans, and Lock 10 at White's Mill before reaching the North Fork Aqueduct on the eastern outskirts of Newark. Its trunk removed, a worker stands on what remains of a pier in 1937. One of the abutments is in the background. (CSO.)

This photograph looks into Newark from the North Fork Aqueduct, with Lock 9 in the center. Few traces of the canal remain at Newark, but Lock 9 was excavated by The Works museum in 2010. The extant lock tender's house is along the towpath at left, while The Works now occupies the lots just beyond the lock. (CSO.)

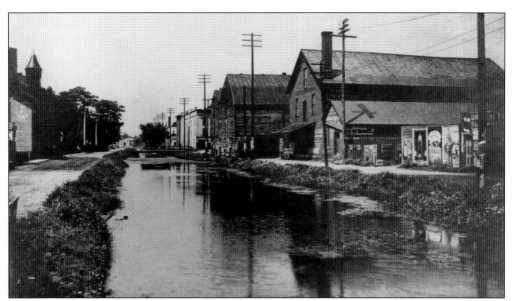

Well established before the arrival of the canal, Newark was founded at the forks of the Licking River in 1802 by Maj. William C. Schenck of Newark, New Jersey, and it became the seat of Licking County in 1808. Before that, Native Americans had constructed one of the largest earthen-mound complexes in the world here. Some of these mounds were ruined by canal construction, which precipitated the development of a major urban center. Warehouses line the canal in the above photograph, which looks west from Lock 9. The distinctive tower of the Licking County Jail is evident on the left. Boats passed the swing bridge at Third Street (below) by bumping into it, causing the bridge to pivot out of the way. The canal at Newark was closed and filled in 1907. (Both, CSO.)

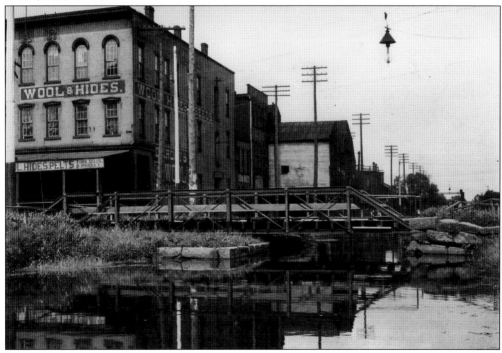

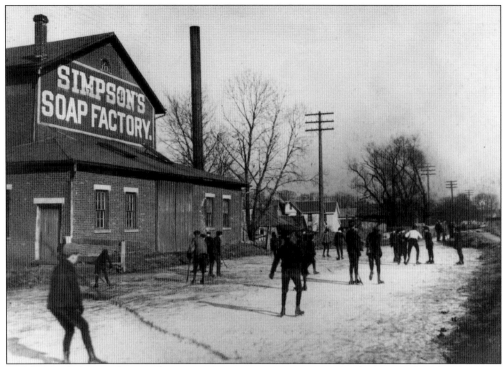

Ice-skaters frolic on the canal at Simpson's Soap Factory on Newark's west side. The Raccoon Creek Aqueduct was located where the canal narrows. This structure was 165 feet long, slightly shorter than the 180-foot-long North Fork Aqueduct on the east side of town. Both were three-span structures built across two piers. (CSO.)

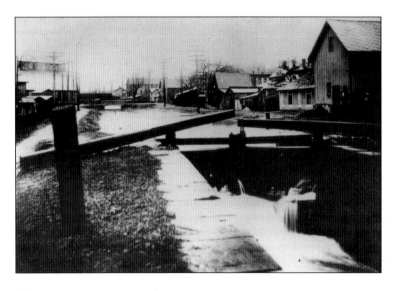

Across Raccoon Creek was the separate community of Lockport, long since absorbed into Newark. The canal made a sharp bend at Eleventh Street and passed through four closely spaced locks at Lockport (Locks 5 to 8). The Wehrle Works factory buildings at left and the distant railroad crossing identify this as Lock 7. (RVF.)

Continuing its climb toward the summit, the canal passed by Great Circle Earthworks at the Licking County Fairgrounds, where Lock 4 was located. Then came Taylor's Locks (Locks 1 to 3, pictured) in modern-day Heath. The landscape is decidedly rural, a stark contrast to today's suburban setting. (CSO.)

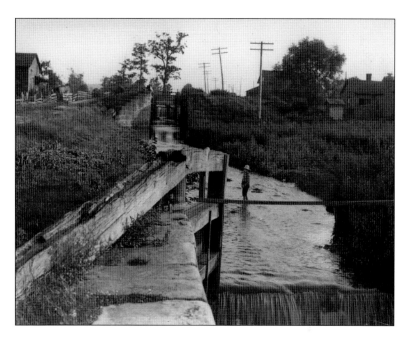

Titled the "Last Canal Boatman at First Locks," this photograph shows what is left of Lock 1 around 1940. Fewer stones remain today, but a historical marker commemorates this as the site where New York governor DeWitt Clinton broke ground on the Ohio and Erie Canal on July 4, 1825. Just above this lock, a six-mile-long navigable feeder from Granville entered the canal. (CSO.)

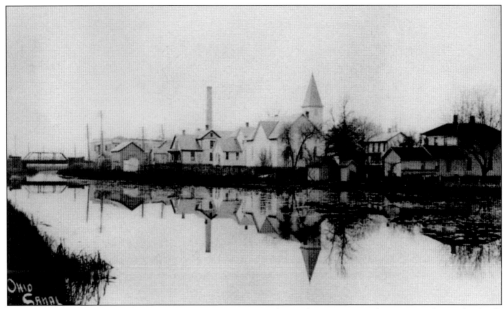

Another important internal improvement project of the early 1800s was the National Road, which crossed the canal at Hebron over the truss bridge in the background. Coincidentally, ground was broken on both the National Road in Ohio and the canal on the same day. This large basin characterized the canal at Hebron, as there were no locks or other significant structures nearby. (Courtesy of Dave Meyer.)

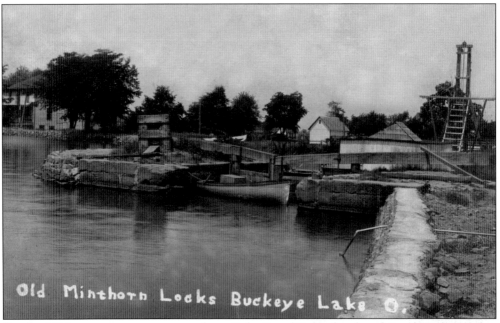

South of Hebron were two more aqueducts, Lake Run (90 feet long) and South Fork (130 feet long). The South Fork, or Kirkersville, Feeder supplemented the water supply on the summit. Another feeder from the North Fork entered the canal near Lock 9 at Newark. Shown here is Minthorn's Lock, removed block-by-block in 1991. (Courtesy of Dave Neuhardt.)

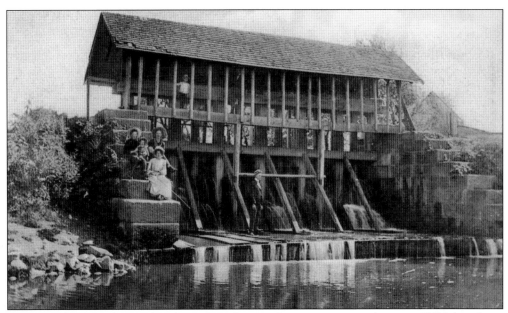

Known today as Buckeye Lake, the Licking Summit Reservoir is at an elevation of 413 feet above the Ohio River at Portsmouth and 160 feet above the Dresden Sidecut Canal at Webbsport. The original reservoir, constructed to impound water for the canal in what was the Buffalo Swamp, covered an area of 2,500 acres, with the towpath crossing along the west embankment. When a 500-acre expansion was built in 1838, the towpath was then routed through the lake along a narrow causeway between Thomas Minthorn's Tavern and Sunfish Point at Millersport. Converted into a state park after the canal was closed, the reservoir has long been a recreational hub. These photographs depict the reservoir's old (above) and new (below) spillways. The latter one has since been replaced. (Above, courtesy of Dave Neuhardt; below, UA-Baus.)

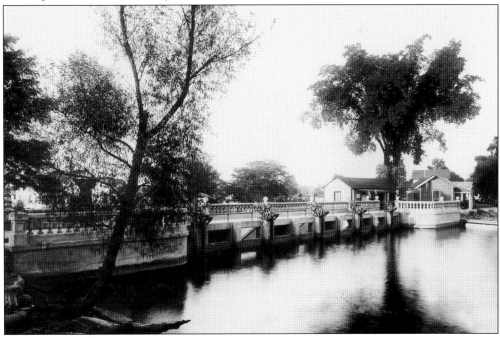

Ports on the Licking Valley and Summit section of the canal included Webbsport, Nashport (south of Frazeysburg in Muskingum County), Lockport, and Millersport, founded in 1825 by Mathias Miller. Shown here is the southern outlet of the canal from the Licking Summit Reservoir at Millersport. The canal then entered a 2-mile-long, 34-foot-deep stretch called the Deep Cut. (CSO.)

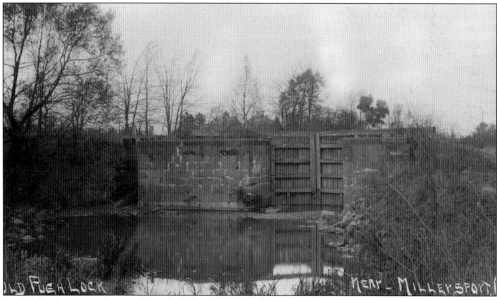

Pugh's Lock was at the south end of the Deep Cut. The 1838 reservoir expansion raised the level of the lake by six feet, requiring the construction of two more lift locks at Minthorn's and Pugh's. Both were called Lock Zero (with respective north and south suffixes) to avoid renumbering. From Pugh's, the canal descended 55 lift locks to the Ohio River at Portsmouth. (Courtesy of Dave Neuhardt.)

Six

LITTLE WALNUT AND UPPER SCIOTO VALLEYS

From Pugh Lock at the southern end of the Licking Summit, the Ohio and Erie Canal descended through the Little Walnut Creek and Upper Scioto River Valleys. There were eight locks each at Baltimore-Basil (Locks 1 to 8), Lockville (Locks 11 to 18), and Lockbourne (Locks 23 to 30). Locks 9 and 10 were at Carroll, where a toll collector's office was located at the junction of the Hocking Canal. Other locks along the canal in this section were between Canal Winchester and Groveport (Locks 19 to 22).

A dam and slackwater crossing provided water to the canal at Lockville. A similar arrangement was located at Millport (Lock 31). Guard locks were positioned at both locations. The 11-mile-long Columbus Feeder provided water to the canal and access to the state capital. More water was provided by the Blacklick Feeder. There was a short aqueduct over Little Walnut Creek near Havensport and a massive one over the Scioto River at Circleville. Lock 32 was at the southern end of the latter aqueduct. More water was provided to the canal by a dam and feeder south of Circleville. The feeder entered the canal just below Locks 33 and 34 at the beginning of an 18-mile level, the longest on the canal. Tollhouses were also stationed at Columbus and Circleville.

Towns along the Ohio and Erie Canal on the 53-mile-long Little Walnut Creek and Upper Scioto Valleys section include Baltimore, Basil, Havensport, Carroll, Lockville, Waterloo, Canal Winchester, Groveport, Lockbourne, Millport, Circleville, Spunkeytown, and Westfall.

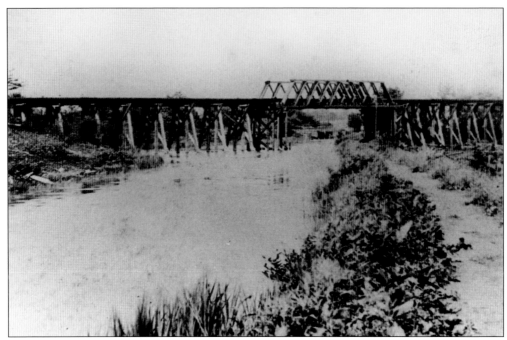

Settlers from Virginia and Switzerland arrived in the Little Walnut Creek Valley near the mouth of Pawpaw Creek in 1825. The Virginians dedicated New Market (incorporated as Baltimore in 1833) east of Pawpaw Creek. A day later, the Swiss established Basil on the west side. Divided by the Market Street Bridge over Pawpaw Creek, these twin cities maintained a rivalry until 1947, when the communities were merged as Baltimore. Some residents wanted to call the town Baseball. Baltimore's Lock 5 is seen in the above photograph, underneath the railroad bridge. The lock was notable because of its excellent dry dock facilities. The large basin likely identifies the below photograph as Lock 6, where Mulnix's (or Smeck's) Mill once operated. This property later became a paper mill, operating today as Ohio Paperboard Corporation. (Above, courtesy of Dave Meyer; below, courtesy of Dave Neuhardt.)

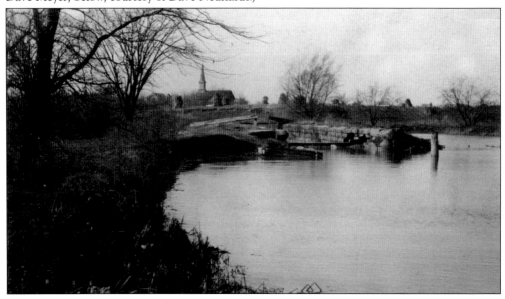

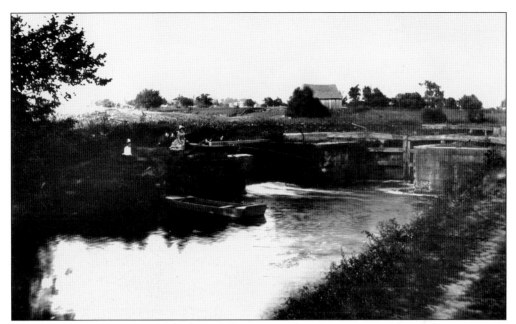

Although there were eight lift locks at Baltimore-Basil, and remnants of five still survive, only Lock 8 remains accessible. Known as Bibler's Lock, it is preserved today in a small village park. Note how the Lock 8 spillway, visible just behind the boat, enters the canal at a perpendicular angle. (Courtesy of Dave Meyer.)

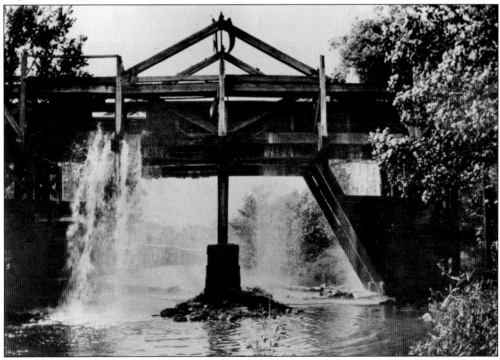

Once a culvert, the crossing of Little Walnut Creek above Havensport was replaced by this unstable-looking truss structure. For a time, the aqueduct flume ran across the top of the culvert's remnants, which created a hybrid structure. Havensport was laid out by Isaac Havens in 1831. (RVF.)

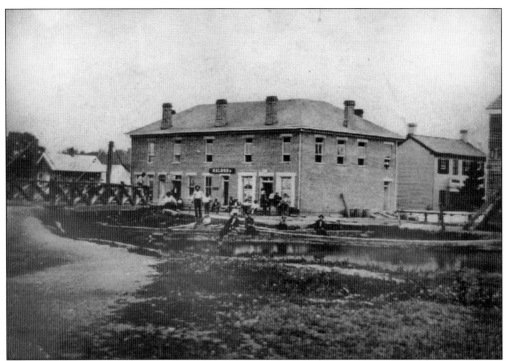

Northwest of Lancaster, the village of Carroll (above) was an important canal junction where the Hocking Canal joined the Ohio and Erie Canal. Abandoned in 1894, the Hocking Canal extended 56 miles to its terminus at Athens. Carroll, founded in 1826 by William Tong, was named after Charles Carroll, a signer of the Declaration of Independence. It was the site of a toll collector's office. The state maintenance boat *Dick Gorham*, a frequently photographed subject from the late canal era in central and southern Ohio, is shown below docked at Carroll. A few courses of stone remain from nearby Lock 10, where Kistler's Flouring Mill once operated. It was the largest in Fairfield County, with a capacity of 150 barrels per day. (Above, courtesy of Dave Meyer; below, CSO.)

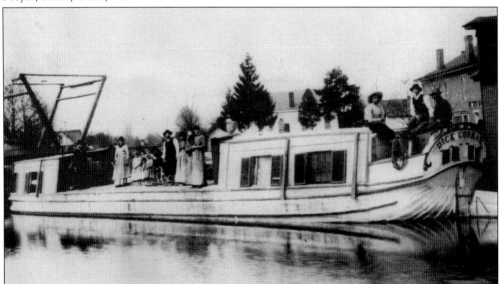

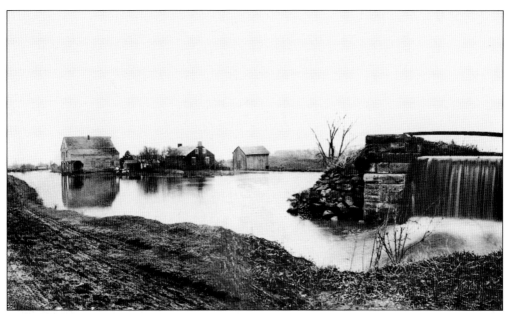

Dropping the canal through Lockville were eight more lift locks (Locks 11 to 18). All eight survive, and three (Locks 11, 12, and 13) have been preserved in the appropriately named Lockville Park. Each of the town's locks, as well as every other lock on the canal, required about 80,000 gallons of water to operate for a single passage. Lock 12 (above) was the site of Mithoff's Distillery. Like Bibler's Lock at Basil (see page 93), Lock 12 also featured a spillway at a right angle to the canal. Below, the white square in the upper chamber of Lock 13 reads, "Built 1862 by Lessees of the Public Works." The plaque is still there today. Mithoff's Distillery buildings can be seen in both photographs. (Both, courtesy of Dave Meyer.)

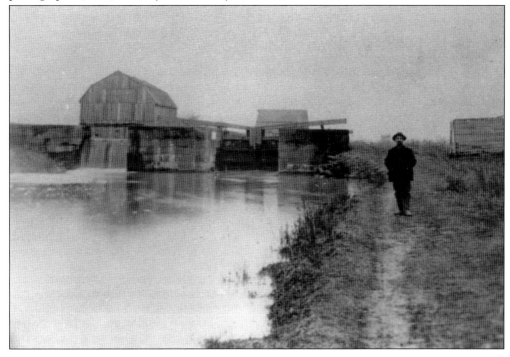

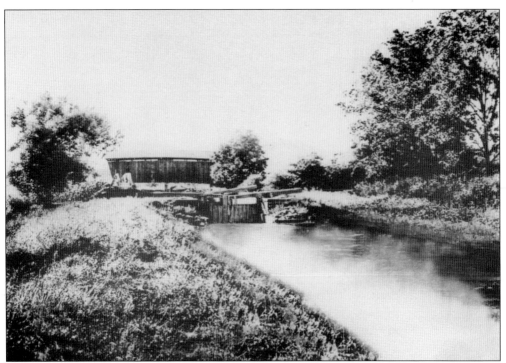

Lock 18 was an outlet lock into a slackwater crossing behind a state dam on Little Walnut Creek. This photograph looks west. Opposite Lock 18 was a guard lock; the dam is out of view to the left. Amanda Northern Road crossed the canal via the covered bridge. (Courtesy of Dave Meyer.)

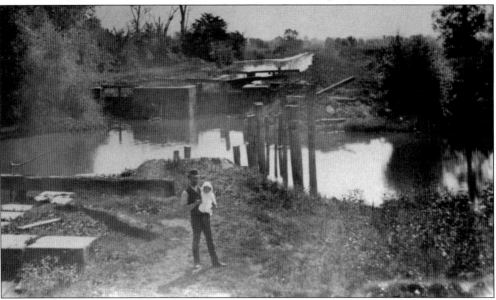

This east-facing photograph shows Lock 18 across the creek, with the unnumbered guard lock in the foreground. The slackwater where boats crossed the creek is between the locks, while the dam is out of the picture to the right. Lock tender John E. Benadum, standing beside the guard lock holding a baby, was responsible for maintaining the locks at Lockville. (Courtesy of Dave Meyer.)

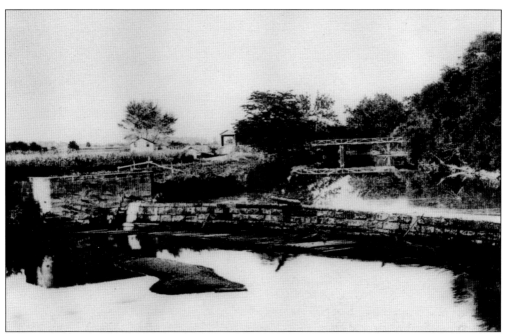

Rare because of its all-stone construction, this is the state dam at Lockville. In the background of this north-facing photograph is the canal crossing. From left to right are lock tender Benadum's family home, the Amanda Northern Road covered bridge, and the towpath bridge crossing Little Walnut Creek. (CSO.)

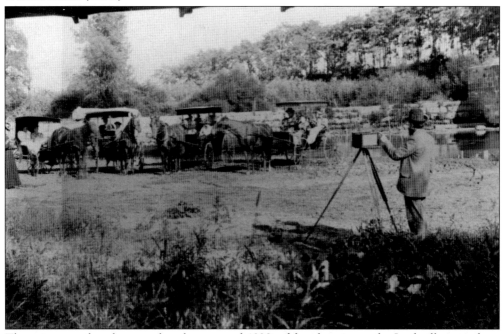

There is a popular photograph, taken around 1898, of four buggies at the Lockville state dam. Shown here is the photographer with his tripod taking that well-known portrait. Water from this dam was introduced through the guard lock and supplied the canal down to Lockbourne. (Courtesy of Dave Meyer.)

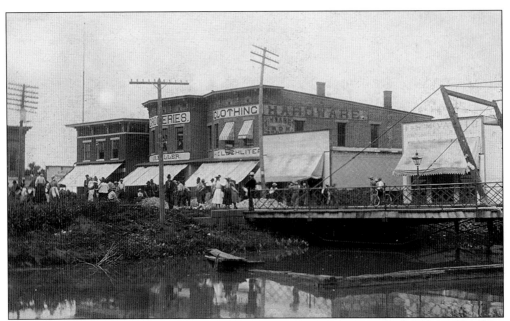

After leaving Waterloo in Fairfield County, the canal continued to Canal Winchester in Franklin County. When the route was announced, Henry Dove and his sons objected so strenuously to the canal bisecting their wheat fields that they threatened to sue the state. Others convinced the Doves that laying out a town might be more profitable than a lawsuit, so Winchester was platted in 1828. Named after Winchester, Virginia, the "Canal" prefix was added in 1841. In the above photograph, businesses line High Street near the turn bridge over the canal. Below, this bridge has been rotated 90 degrees to allow for passage of a boat. In the background is the Carty and Rogers Warehouse. Established in 1835 and razed in 1902, this was commonly known as the red warehouse. A competing yellow warehouse was built in 1842. (Both, courtesy of Dave Meyer.)

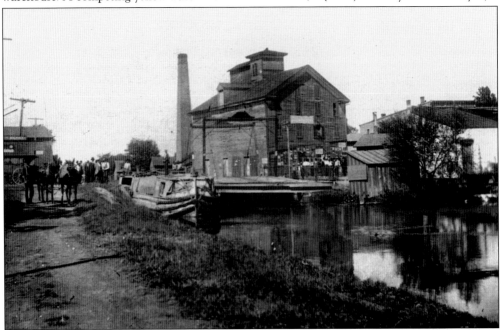

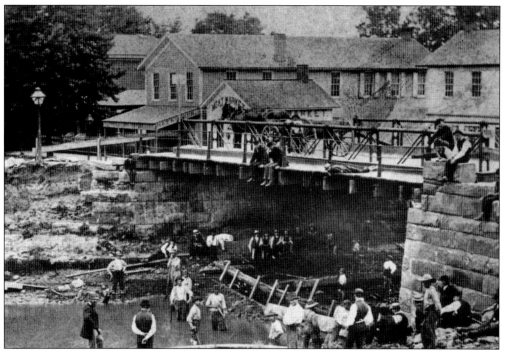

Workers pose at the High Street Bridge in this photograph, taken prior to the one on the previous page. This stationary high bridge was moved in 1883 to Groveport, where it was placed over the canal at East Street. Milepost 210 was directly under the bridge at High Street, indicating that Canal Winchester was exactly 210 miles from Cleveland along the canal route. (Courtesy of Dave Meyer.)

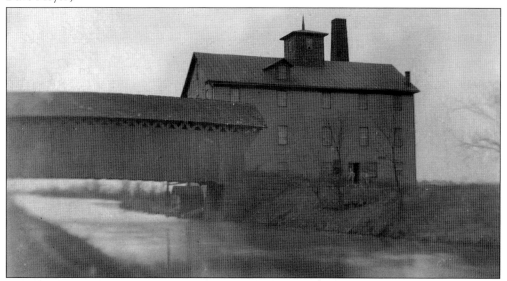

Empire Mills, about a mile below Canal Winchester, derived its waterpower from the spillway of Lock 19. Tracks from the interurban line of the Scioto Valley Traction Company later ran along the berm bank of the canal, opposite the towpath, between Canal Winchester and Groveport. Below Lock 21, the Blacklick Feeder further supplemented the canal's water supply. (Courtesy of Dave Meyer.)

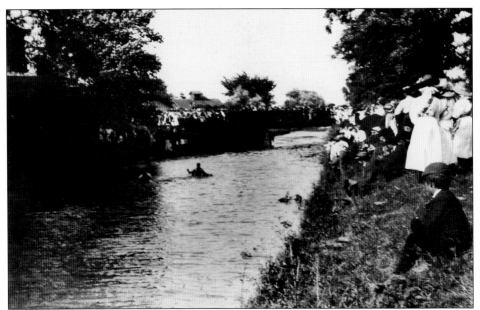

Adam Rarey built a log tavern in what is today Groveport around 1812. After the canal opened in 1831, Jacob B. Wert established a warehouse, store, and post office he called Wert's Grove. The Rareys requested that mail be addressed to Rareysport, but postmaster Wert changed the addresses on the letters to read Wert's Grove. Citizens reached a compromise when the village was incorporated in 1847 by combining Rareysport and Wert's Grove into Groveport, thus removing both rival families from the new name. (Some consideration was given to Palo Alto, a recently won battle of the Mexican-American War). The recreational activity of a tub race (above) and the serious commercial enterprise of ice cutting (below) are depicted on the canal at Groveport. Nearby Lock 22 survives, and it may be accessed by walking along the old interurban line from Blacklick Park. (Both, UA-Baus.)

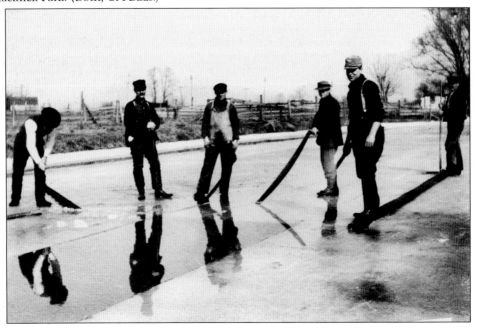

Another town in the Little Walnut and Upper Scioto Valleys section with a staircase of eight locks (Locks 23 to 30) is Lockbourne. Of the locks, four survive. Lock 30 in Lock Meadow Park is the most accessible today. This photograph is thought to depict one of the locks at Lockbourne, located at the junction of the Columbus Feeder and the Ohio and Erie Canal. (CSO.)

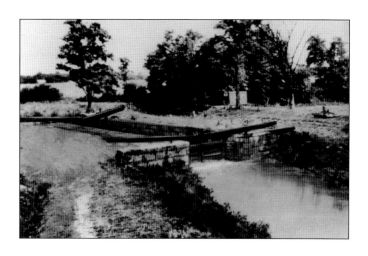

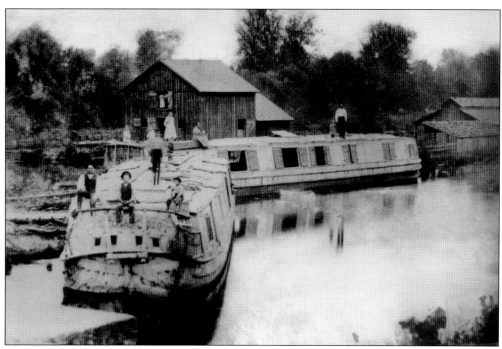

Col. James Kilbourne incorporated his name into the canal village when surveying it in 1831. Kilbourne was surveying for a church, but taverns became so pervasive here that Lockbourne earned a rather dubious reputation. The Canal House Hotel and Moneypenny's Distillery were two significant canal-era enterprises. Shown here are the Nye family boats at Lockbourne, including the *Tom Marfield* in the foreground. (RVF.)

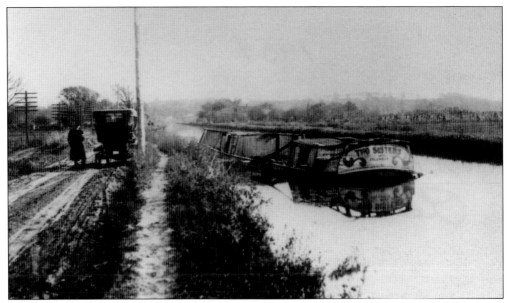

Likely one of the last boats to travel along the Columbus Feeder, the *Two Sisters* of Columbus is visited by an early automobile. Opened in 1831 and abandoned in 1904, this 11-mile-long feeder provided access to the Ohio and Erie Canal for Columbus. Prison laborers from the state penitentiary built a one-mile section of the feeder. (RVF.)

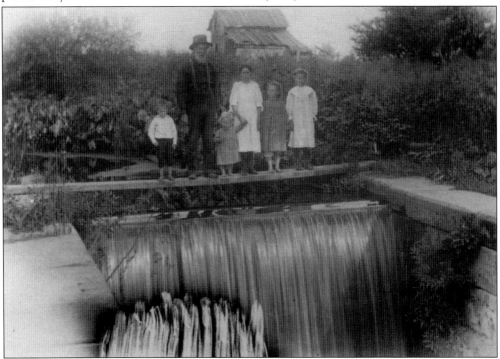

Boats accessing the feeder had to pass through a guard lock and behind a dam on Big Walnut Creek at Lockbourne. There were two lift locks on the Columbus Feeder, one at Lockbourne and the other four miles south of the feeder terminus at Columbus. This family photograph was taken on the spillway of the second lock, called Four Mile Lock. (CSO.)

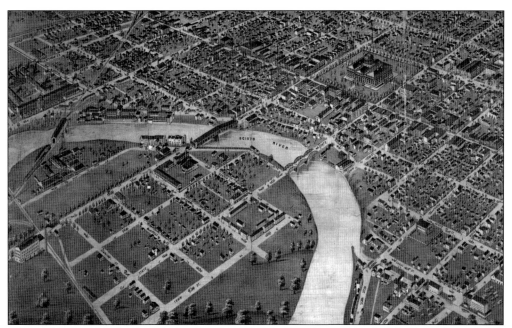

This early map of Columbus shows the original Ohio Statehouse (upper right) and the terminus of the Columbus Feeder into the Scioto River (lower right). Desiring a seat of government in the center of the state, the legislature created Columbus in 1816 as Ohio's state capital. Delaware, Dublin, Franklinton (across the river from Columbus), and Worthington unsuccessfully vied to become the capital. (Courtesy of Dave Meyer.)

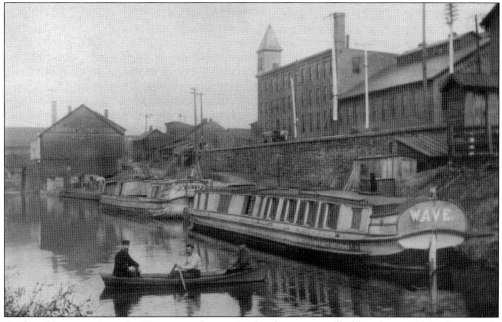

Enclosed boats such as the *Wave*, seen here at Columbus, were called line boats. This photograph looks north toward the Scioto River at Friend Street (now Main Street). The building with the steeple is the Jackson Guldan Violin factory, torn down in 1973. This area is now Columbus's John W. Galbreath Bicentennial Park. (CSO.)

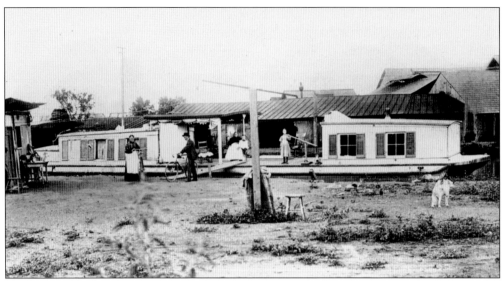

At Lockbourne, the canal joined the Scioto Valley, but it made a final crossing of Little Walnut Creek at Millport, north of Circleville. The guard and lift lock (Lock 31) slackwater crossing arrangement at Millport was similar to those at Lockville on the main line of the canal and at Lockbourne on the feeder. Lock 31 is the only extant canal lift lock in Pickaway County. The county seat and commercial center of Pickaway County is Circleville. Laid out by Daniel Dresbach in 1810 around an ancient Native American earthwork, an octagon-shaped courthouse once sat atop the circular mound, while streets ran in a series of concentric circles and spokes radiating from this hub. Circleville had been "squared" into a conventional grid by 1856. Both photographs depict state boats at Circleville. (Above, UA-Baus; below, courtesy of Dave Meyer.)

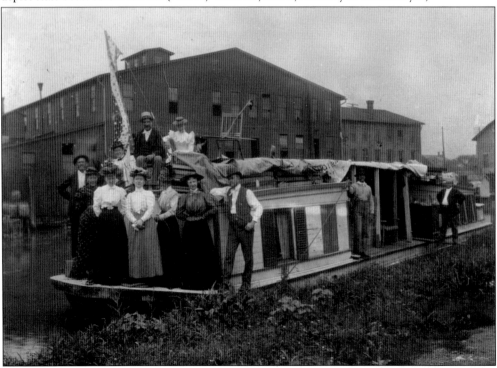

Its location in the heart of a rich corn-growing area made Circleville a pork-processing center. The John Groce & Son Pork Packers Company stood beside the canal at High Street. At its peak in the 1840s, Circleville slaughterhouses processed 40,000 hogs annually. Groce's factory shut down in 1889. (Courtesy of Dave Meyer.)

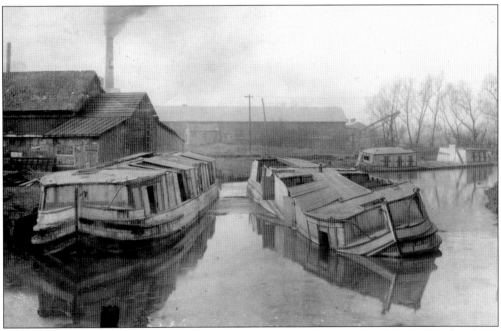

There was a basin at the south end of Circleville at Mound Street, where the canal made a sharp bend to cross the Scioto River. This basin eventually became a boat graveyard. Three types of canal boats are represented in this photograph: a line boat (left), a cargo boat (center), and a state boat (background, right). (Courtesy of Dave Meyer.)

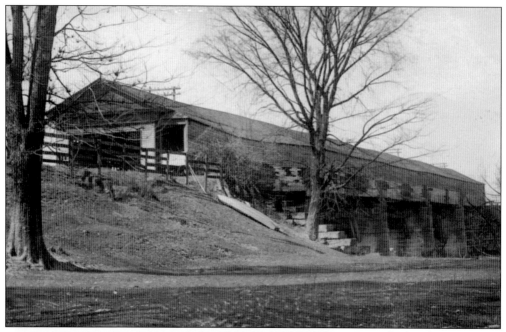

From the bend at the Mound Street Basin, the canal turned to cross the river south of town over the Great Scioto, or Circleville, Aqueduct. This impressive structure was the longest aqueduct along the entire canal, at 440 feet long, with each span 88 feet across. This photograph of the east portal shows the whole aqueduct and its four piers. (Courtesy of Dave Meyer.)

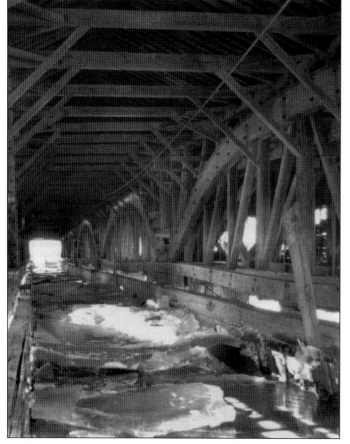

Mules pulled boats through this covered structure from the towpath on the north, or upstream, side of the aqueduct. It could be a bottleneck. Only 20 feet wide, boats could not pass inside the Circleville Aqueduct. And due to its shallow depth, any boat traveling fast enough to create a sufficient wake would be grounded on the bottom. (Courtesy of Dave Meyer.)

Engineers wanted to cross the river above Circleville, which would have been cheaper. This crossing was necessary to appease Chillicothe, which is on the west side of the river. To avoid being bypassed, Circleville citizens collected a $3,500 subscription to guarantee the canal would cross the river south of their town. In this photograph of the aqueduct, icicles form a wall of ice. (CSO.)

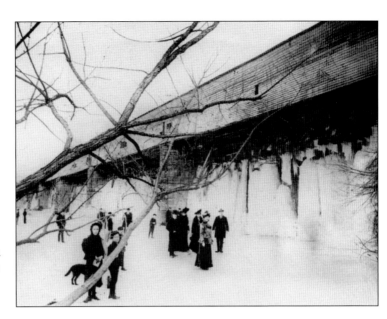

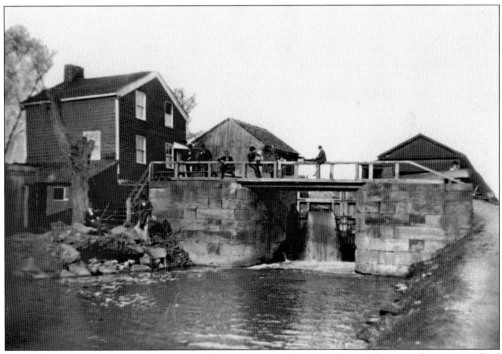

Lock 32 was at the western end of the Circleville Aqueduct. Built into the west abutment, it had a lift of nine and a half feet. Also shown are the lock tender's house (left), change bridge over the lock chamber (center), and towpath (right). Nearby was the milling village of Spunkeytown. (Courtesy of Dave Meyer.)

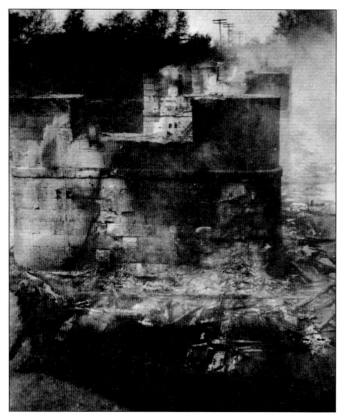

The Circleville Aqueduct suffered a rather ignominious end. Operating as a gaming house, it survived the closing of the canal and the 1913 flood, only to be burned down on April 27, 1915. Shown here are the smoldering ruins. According to legend, the blaze was started by a spiteful gambler. All that remains today is the east abutment, an impressive ruin. (Courtesy of Dave Meyer.)

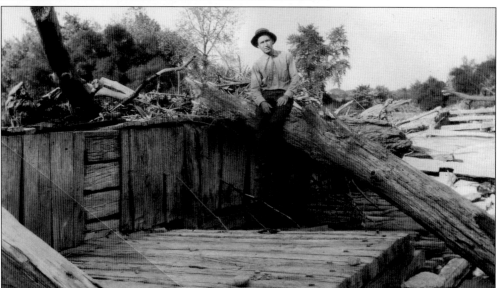

Choked with debris is the Circleville Dam, another dam and feeder system to augment the canal's water supply. A feeder entered the canal just below Locks 33 and 34, at the head of an 18-mile level down to Frenchtown. Today, a three-mile-long watered section of the Ohio and Erie Canal still exists from the Circleville dam to Westfall, near the Pickaway-Ross County Line. (Courtesy of Dave Meyer.)

Seven

Lower Scioto Valley

The Ohio and Erie Canal entered Ross County along an 18-mile level between the Circleville Dam and Frenchtown (Locks 35 and 36). Aqueducts over Yellowbud Creek and Deer Creek were on this level. Chillicothe's two locks were located at Fourth Street (Lock 37) and Fifth Street (Lock 38). Leaving Chillicothe, the canal crossed Paint Creek over another aqueduct before passing through the two locks at Lunebeck's (Locks 39 and 40). All water for the canal to its terminus at Portsmouth was provided by a state dam at Three Locks (Locks 41 to 43) in southern Ross County.

Waverly was home to Lock 44 and the Crooked Creek Aqueduct. South of town was the Pee Pee Aqueduct and two locks (Locks 45 and 46). Lock 47 was at Coopersville, Locks 48 and 49 at Rushtown, and Locks 50 to 52 at Bertha (now West Portsmouth). Other Portsmouth locks were Elbow Lock (Lock 53) and Red Bridge Lock (Lock 54). The outlet lock was Lock 55. Originally, this led into the Scioto River opposite Portsmouth, but after 1887, it went directly into the Ohio River two miles west of town. Other aqueducts in this section were at Stony Creek, Moores Run, Sunfish Creek, Camp Creek, Bear Creek, and Scioto Brush Creek. These were originally culverts but were later converted into aqueducts to create more clearance and avoid problems with flooding. Tollhouses were at Chillicothe, Waverly, and Portsmouth.

Towns along the Ohio and Erie Canal on the 63-mile-long Lower Scioto Valley section include Andersonville, Frenchtown, Chillicothe, Three Locks, Higby, Omega, Waverly, Jasper, Coopersville, Rushtown, Bertha (West Portsmouth), and Portsmouth.

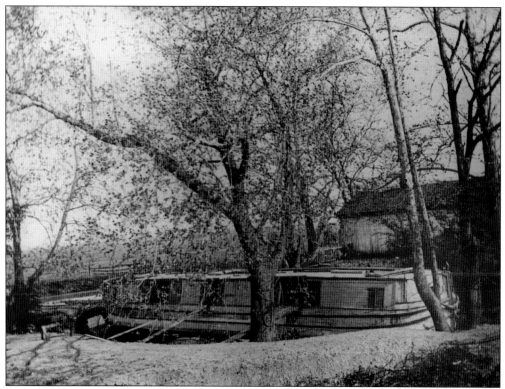

According to folklore, this small village in extreme northern Ross County was originally called Forsythia but changed to Yellowbud since nobody could spell or pronounce the name. An aqueduct, basin, and dry dock were at Yellowbud. Shown here is the line boat *Bluebird* in the Yellowbud dry dock. (Courtesy of Dave Meyer.)

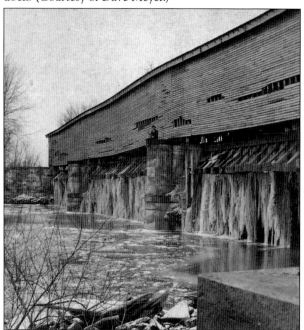

Farther down the canal was this aqueduct over Deer Creek, which was covered like the one at Circleville. Nearly 200 feet long, this aqueduct was on the 18-mile level below the Circleville Dam. This was the longest level (in terms of distance between locks) on the entire Ohio and Erie Canal. The canal village of Andersonville was two miles south of the Deer Creek Aqueduct. (Courtesy of Dave Meyer.)

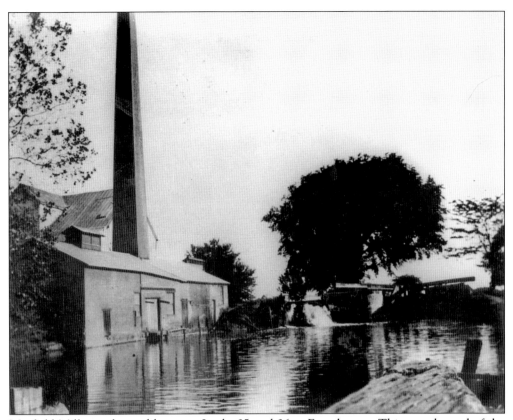

Marfield Mills was located between Locks 35 and 36 at Frenchtown. This was the end of the 18-mile level south of Circleville. Later converted into Camp Sherman, a World War I US Army training facility, Frenchtown is now the site of Hopewell Culture National Historic Park. (Courtesy of Dave Meyer.)

These two boys peek out from under the balance beam on the gates of Lock 36 at Frenchtown. The dedication stone pays homage to Henry Clay, who advocated federal funding for internal improvements. Abraham Lincoln idolized Clay as "my beau ideal of a statesman." (CSO.)

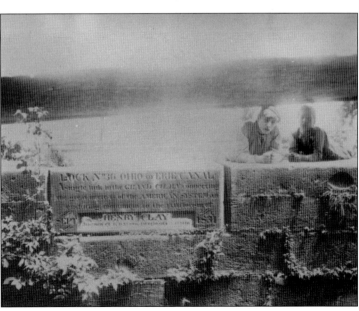

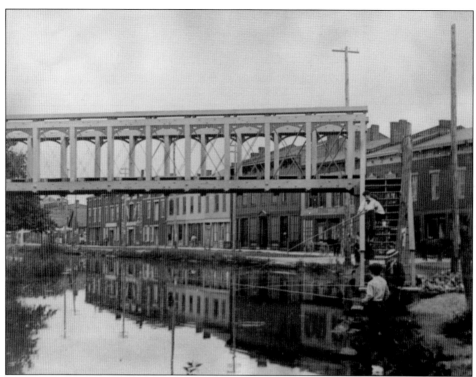

The seat of Ross County and the birthplace of Ohio statehood, Chillicothe was founded in 1796 by Nathaniel Massie, principal surveyor for the Virginia Military District. Named from the Shawnee *chalaqwatha*, which means "chief town," Chillicothe was Ohio's first capital. Although the capital moved to Columbus in 1816, Chillicothe retained enough political influence to have the canal routed along the western side of the Scioto River below Circleville. The *Dolphin* and the *General Worthington*, the first boats built at Chillicothe, led a flotilla of 10 boats during a grand celebration when the canal opened on October 22, 1831. The canal closed at Chillicothe in 1907. These photographs show the Water Street business district when the canal was in operation. (Above, CSO; below, UA-Baus.)

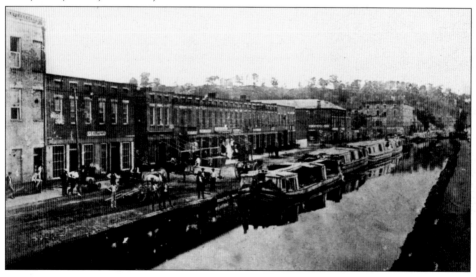

The canal came into Chillicothe along modern-day Yoctangee Parkway, then made a bend at Walnut Street to follow Water Street for two blocks. This photograph looks west along Water Street. Buildings on Water Street abutted the canal until 1852, when the central business district was rebuilt after a fire. (CSO.)

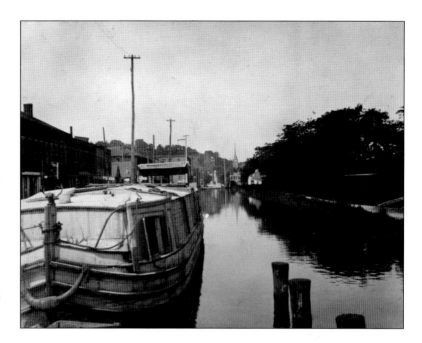

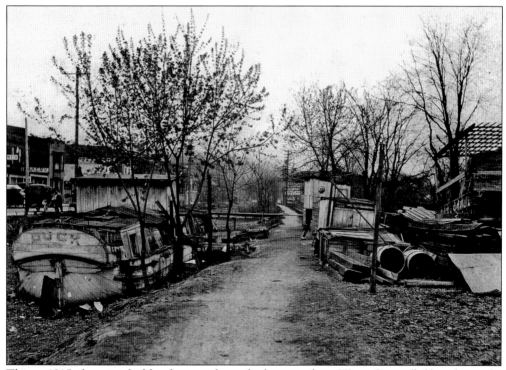

This c. 1915 photograph, like the one above, looks west along Water Street (left) and straight down the towpath. Abandoned where it sat in the canal bed after the 1907 closing, the *Duck* (left) was home to canal boatman Faddy Schwartz for many years. The *Duck* was parked at Paint Street, midway between Walnut and Mulberry Streets. (Courtesy of Dave Meyer.)

At the intersection of Water and Mulberry Streets, the canal made a 90-degree bend. Negotiating such a sharp turn was a tricky task, requiring the use of poles to keep boats from running into the canal bank. This turn bridge was angled to serve both streets. It was maintained by a bridge keeper (shown shoveling snow off the bridge). His shack is at right. (CSO.)

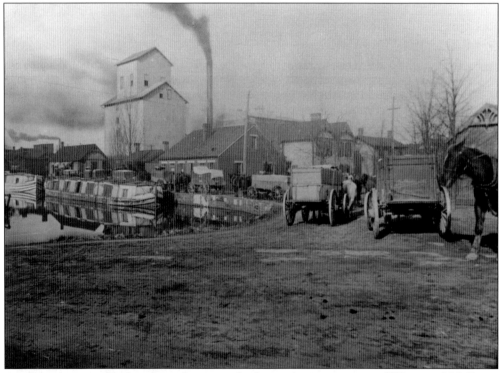

Another photograph taken from the corner bridge at the intersection of Water and Mulberry Streets shows a line of canal boats unloading at Chillicothe's Standard Cereal Mills in 1903. From here, the canal headed south along Mulberry Street for two blocks before making a jog to the east. (CSO.)

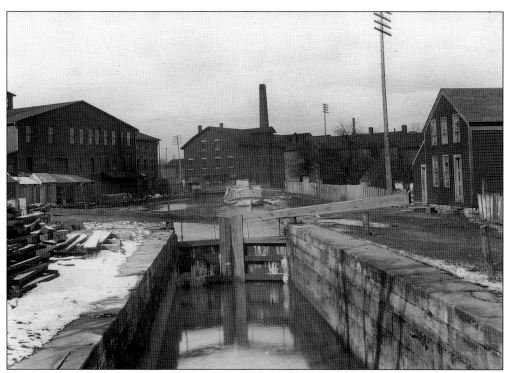

Directly behind the boat in the basin above Lock 37 at Fourth Street is a row of canal warehouses. This photograph looks north toward Main Street. At left is the Sears and Nichols canning factory. The Fourth Street area was known as the Corn Exchange, but Pearl Nye called it something else, referring to its "rooster nests" in one of his songs. (CSO.)

Shown here is Lock 38, located at Fifth Street. It was one block south of Lock 37, at Fourth Street. The lock tender's house (left) is a rare surviving remnant of the canal at Chillicothe. Below Lock 38 was a hydraulic race, where a paper mill was established in 1847. It was purchased by Daniel Mead in 1890, and Mead Corporation operations were consolidated at the Chillicothe mill by 1907. (CSO.)

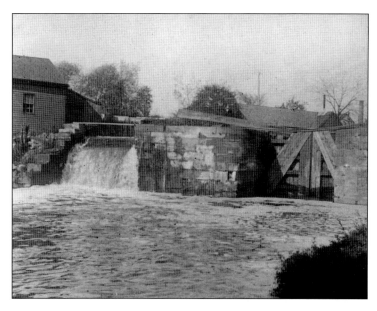

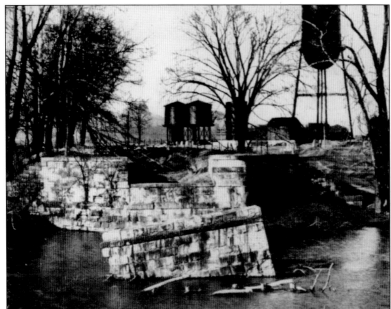

Paint Creek is the largest tributary of the Scioto River. The canal crossed this formidable stream a couple of miles south of town. Its trunk washed away by the 1913 flood, the 272-foot-long Paint Creek Aqueduct was the third longest on the canal. Only those at Circleville and Roscoe were longer. (CSO.)

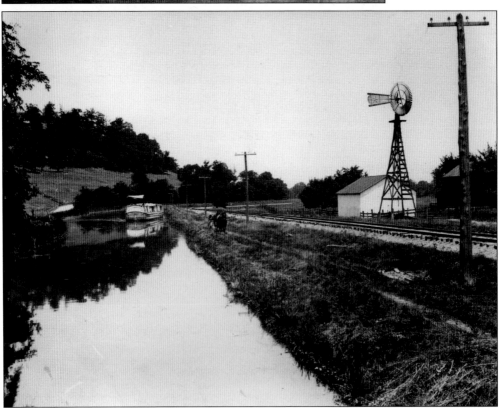

There were two more lift locks (Locks 39 and 40) south of the Paint Creek Aqueduct near Lunebeck's Mill. During the 1880s, when this photograph was taken, this was the Kidnocker's Farm; today, it is overshadowed by the Bridge Street interchange of US Route 23. There is no explanation for why the boat shown here is being towed backward. (CSO.)

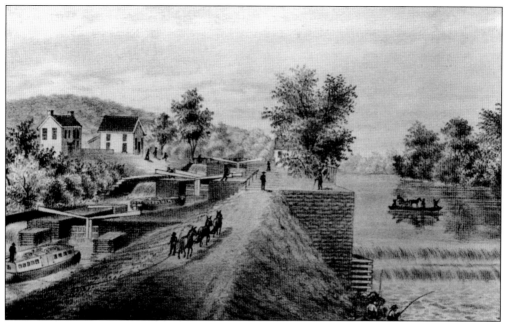

Variously known as Pin Hook, State Dam, Tomlinsons, and Vidal, the final dam and feeder system along the Ohio and Erie Canal was located at Three Locks. Water impounded behind this 504-foot-long dam (right) across the Scioto River was sufficient to supply the canal for another 45 miles, to its terminus at Portsmouth. Locks 41 to 43 are at left in this engraving. (CSO.)

Higby, at the head of Big Bottom, was the southernmost canal community in Ross County before the canal entered Pike County. After crossing a short 42-foot-long aqueduct over Moores Run, the canal next came to the settlement of Omega (formerly Sharonville). Pictured here is Humphrey's Mill and General Store at Omega. A stone canal culvert survives at Omega where Ohio Route 335 crosses Wilson Run. (Courtesy of Dave Meyer.)

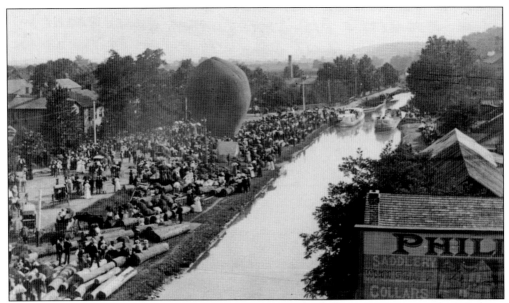

Before the Wright brothers invented heavier-than-air flight, balloon ascensions, such as this one at Waverly, were popular events. Of interest to "canawlers" are the two state boats parked in the background. Where the canal narrows just behind the boats is the Crooked Creek Aqueduct. This photograph is looking south. (Courtesy of Dave Meyer.)

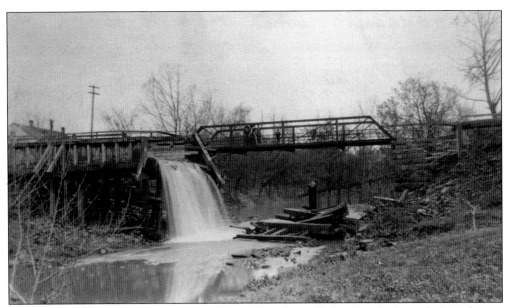

Leaking profusely after losing its trunk in the 1913 flood is the Crooked Creek Aqueduct at Waverly. Founded in 1829 by Mesheck Downing as Uniontown, the town's name was changed to Waverly as a tribute to Sir Walter Scott's popular Waverly series of novels. Local entrepreneur James Emmitt was influential enough to have the Pike County seat moved from Piketon to Waverly in 1861. (Courtesy of Dave Meyer.)

James Emmitt, owner of at least 19 canal boats and the Lower Scioto Valley's first millionaire, built an industrial park in the basin below Lock 44 (shown). Emmitt made his fortune shipping goods via the canal. He also had an interest in multiple commercial and manufacturing ventures. Some stones from Lock 44 survive in Waverly today, but the historic Emmitt House was destroyed in 2014. (CSO.)

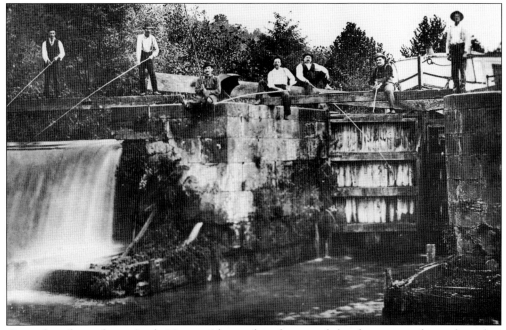

Once thought to depict Lock 16 near Akron, this photograph has been recently confirmed to show Lock 45, south of Waverly. The boat in the lock chamber is the *Friendship*, captained by J. Hayes. He is at the right of the photograph, the only man not holding a fishing pole. (CSO.)

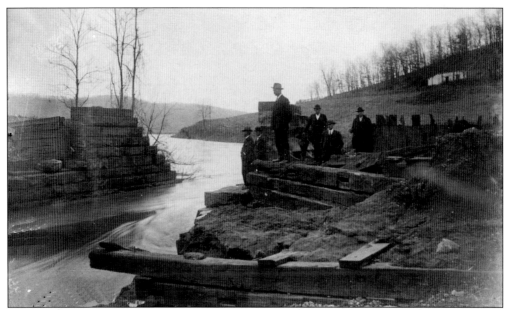

Flooding problems associated with the crossing of Pee Pee Creek are described at length in reports of the Board of Public Works. After the original stone culvert washed out in 1875, it was replaced with a 100-foot-long aqueduct. This photograph proves that this did not solve the problem. (Courtesy of Dave Meyer.)

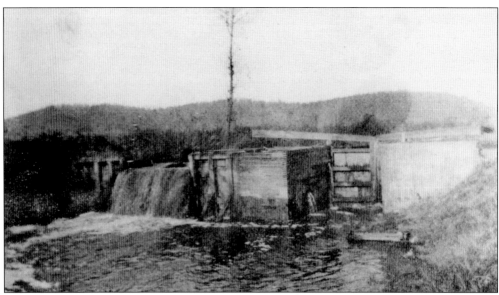

Because of persistent floods on Pee Pee Creek (named for the initials of pioneer settler Peter Patrick), canal structures here were cheap and easily replaceable. This resulted in Lock 46 being the only wood lock on the Ohio and Erie Canal. Lock 46, shown in this rare photograph, is now rotted away at the bottom of Lake White. (Courtesy of Dave Meyer.)

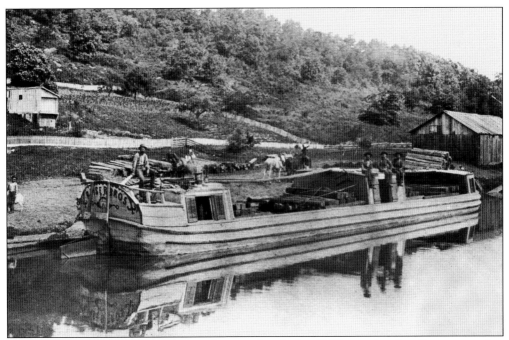

While much of the canal south of Dresden was closed after 1907, some local traffic continued to operate along isolated sections in southern Ohio. This was particularly true for the lumber trade around Jasper, where timber reserves were abundant, as illustrated by this boat, *Reiser Bros.* (UA-Baus.)

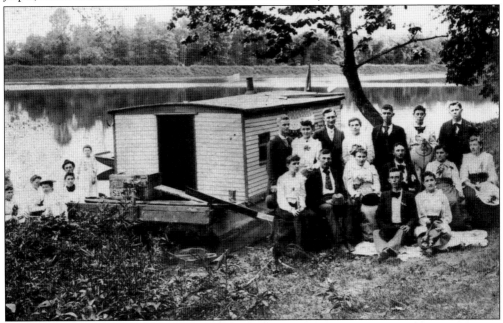

Ohio governor Robert Lucas founded Jasper in 1833 as a speculative venture. There was a 700-foot-wide basin north of the village, where this group poses in front of an unusual-looking boat. Jasper's biggest day of excitement came on July 16, 1863, when John Hunt Morgan's Confederate raiders paid a visit. The rebels executed a local citizen as a spy and burned several buildings. (Courtesy of Dave Meyer.)

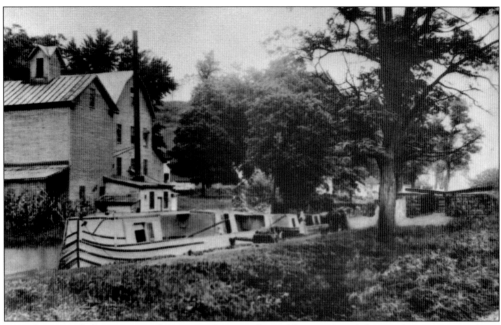

Traveling south from Jasper, boats on the canal would cross Sunfish Creek on an aqueduct, descend through Lock 47, pass the village of Coopersville, enter Scioto County, then cross two more aqueducts at Camp Creek and Bear Creek before reaching Lock 48 (background, right) at Brown's Mill, just above Rushtown. (RVF.)

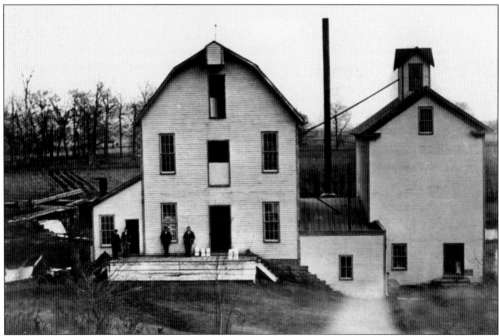

This is another view of Brown's Mill, north of Rushtown, looking east toward the Scioto River from the county road (now Ohio Route 104). Although improvements to the road wiped out many canal structures between Waverly and Portsmouth, Lock 48 survives and is in relatively good condition. (UA-Baus.)

Rushtown is situated at the mouth of Scioto Brush Creek, where another aqueduct crossing was required. This topside view shows the 100-foot-long aqueduct (right) on the canal. The covered bridge (left) is on the county road. Similar to other aqueducts in this region, the Brush Creek Aqueduct started as a triple-arch stone culvert, but it had to be replaced due to incessant flooding. (CSO.)

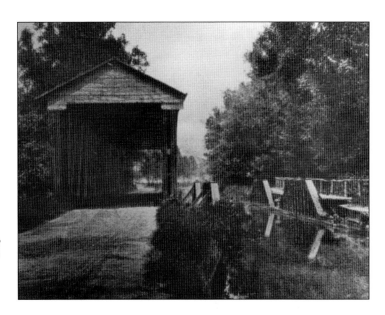

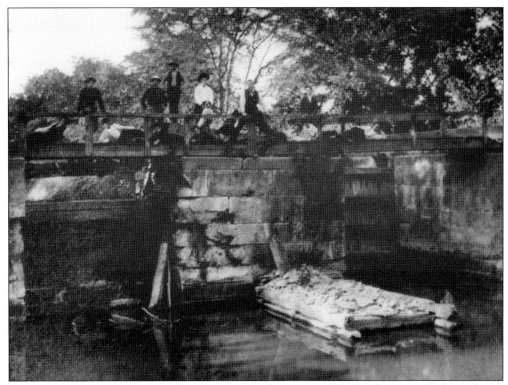

Rushtown was named in honor of Dr. Benjamin Rush, a signer of the Declaration of Independence. Earlier names for this canal community included Falls of Scioto Brush Creek, Lucas Ferry, and Walnut Forge. A black-powder mill once operated at Lock 49 (pictured). An explosion destroyed the gunpowder mill years ago, but this lock remains. (RVF.)

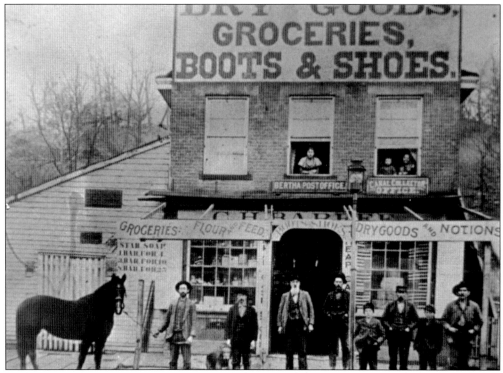

Neal Barbee operated this store at Union Mills. Barbee was also postmaster and toll collector, as indicated by signs under the upper-story windows reading "Bertha Post Office" and "Canal Collector's Office." Barbee became the toll collector in 1890, when the office was moved from downtown Portsmouth. The post office opened in 1895. (Courtesy of Dave Meyer.)

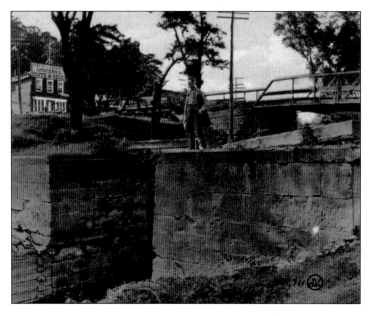

Visible in the left background is the Portsmouth toll collector's office. Lock 51 is in the foreground. This was the middle of three locks at Bertha (now West Portsmouth). Both Locks 51 and 52 have been removed, but Lock 50—the southernmost surviving lock on the Ohio and Erie Canal—has been nicely preserved. A historical marker, old milepost, and canal mural are here today. (Courtesy of Dave Neuhardt.)

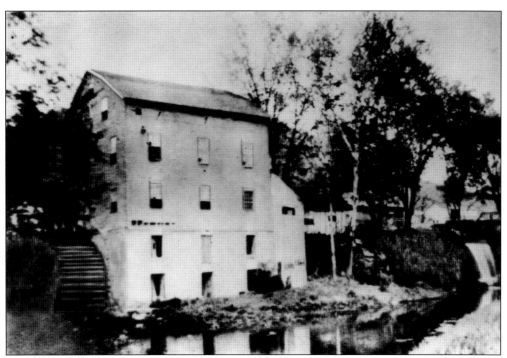

Union Mills at Bertha operated along the spillway around Locks 50 and 51, taking advantage of a 17-foot drop. It was established in 1834 by Lemeul Moss. George Davis purchased both Union Mills and the nearby Scioto Distillery in 1859. The mill was eventually owned by Neal Barbee, and the distillery fell under the control of a whiskey trust. (CSO.)

A panoramic view of West Portsmouth shows Lock 52, Union Mills, Towpath Road, and Sugar Loaf Hill in the background. Towpath Road crossed the Scioto Bottoms, past Lock 53, or Elbow Lock, and continued on to the suspension bridge at the mouth of the Scioto River, opposite Portsmouth. Towpath Road is now Ohio Routes 73 and 104. (CSO.)

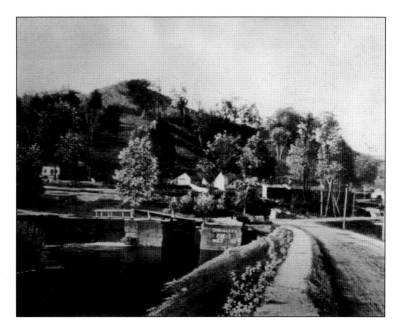

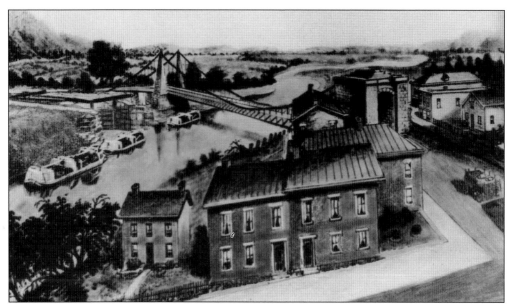

As at Cleveland 309 miles away, the terminus of the Ohio and Erie Canal was also moved. This southern terminus was at Portsmouth, founded by Henry Massie in 1803. The original outlet (above) from 1832 to 1887 was at the mouth of the Scioto River opposite Portsmouth, but it was plagued by flooding problems. So a new channel was cut, complete with an elaborate double-chambered outlet lock, providing direct access to the Ohio River. The outlet lock was formally dedicated on November 13, 1887 (below). Just why so much money was invested in constructing this new outlet when the canal was seldom used at this point remains a mystery. Legend states that only one canal boat actually passed through it. Portsmouth's history is defined by its floods, which thwarted its development into a major inland port city. (Above, RVF; below, courtesy of Dave Meyer.)

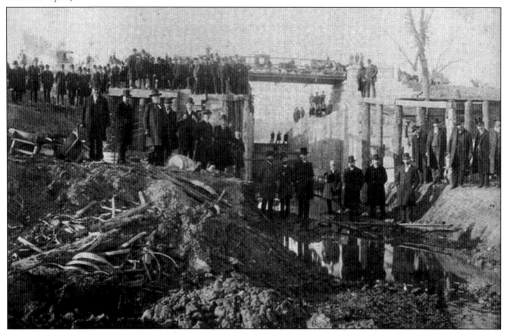

BIBLIOGRAPHY

Gieck, Jack. *A Photo Album of Ohio's Canal Era, 1825–1913.* Kent, OH: Kent State University Press, 1988 (Rev. ed. 1992).

———. *Early Akron's Industrial Valley: A History of the Cascade Locks.* Kent, OH: Kent State University Press, 2008.

Hagerty, J.E., C.P. McClelland, and C.C. Huntington. *History of the Ohio Canals: Their Construction, Cost, Use, and Partial Abandonment.* Clarified and copyrighted 1992 by Arthur W. McGraw. Columbus: Ohio State Archaeological and Historical Society, 1905.

Metzger, Lynn, and Peg Bobel, eds. *Canal Fever: The Ohio & Erie Canal from Waterway to Canalway.* Kent, OH: Kent State University Press, 2009.

Meyer, David A. *Licking Reservoir to Lockbourne and Columbus Feeder.* Canal Winchester, OH: Canal Winchester Historical Society, 1998.

———. *Life Along the Ohio Canal in the Scioto Valley.* Canal Winchester, OH: Canal Winchester Historical Society, 2007.

Scheiber, Harry N. *Ohio Canal Era: Case Study of Government and the Economy, 1820–61.* Athens: Ohio University Press, 1969.

Trevorrow, Frank. *Ohio's Canals.* Oberlin, OH: Self-published, 1973.

Woods, Terry K. *Ohio's Grand Canal: A Brief History of the Ohio & Erie Canal.* Kent, OH: Kent State University Press, 2008.

———. *The Ohio and Erie Canal: A Glossary of Terms.* Kent, OH: Kent State University Press, 1995.

———. *The Ohio & Erie Canal in Stark County.* Massillon, OH: Massillon Museum, 2003.

DISCOVER THOUSANDS OF LOCAL HISTORY BOOKS
FEATURING MILLIONS OF VINTAGE IMAGES

Arcadia Publishing, the leading local history publisher in the United States, is committed to making history accessible and meaningful through publishing books that celebrate and preserve the heritage of America's people and places.

Find more books like this at
www.arcadiapublishing.com

Search for your hometown history, your old stomping grounds, and even your favorite sports team.

Consistent with our mission to preserve history on a local level, this book was printed in South Carolina on American-made paper and manufactured entirely in the United States. Products carrying the accredited Forest Stewardship Council (FSC) label are printed on 100 percent FSC-certified paper.

MADE IN THE USA